The Campus History Series

UNIVERSITY OF
NEBRASKA AT OMAHA

On the front cover: Don Ellis and Friends perform on the north side of the university administration building on Thursday afternoon, September 23, 1971. The group from North Hollywood, California, numbering 22, combined woodwinds, brass, strings, piano, electric bass, and four sets of drums to create, in the words of the *Gateway*, "probably the finest" performance "in UNO music history." The four-time Grammy award winners performed for an estimated audience of 500. (Courtesy of the University of Nebraska at Omaha Archives.)

Cover background: Please see page 58. (Courtesy of the University of Nebraska at Omaha Archives.)

The Campus History Series

UNIVERSITY OF NEBRASKA AT OMAHA

OLIVER B. POLLAK AND LES VALENTINE

ARCADIA
PUBLISHING

Published by Arcadia Publishing
Charleston, South Carolina

Printed in the United States of America

Library of Congress Catalog Card Number: 2006938880

For all general information contact Arcadia Publishing at:
Telephone 843-853-2070
Fax 843-853-0044
E-mail sales@arcadiapublishing.com
For customer service and orders:
Toll-Free 1-888-313-2665

Visit us on the Internet at www.arcadiapublishing.com

*To our wives, Karen Goldstein Pollak and Carol Gutchewsky,
and to the fulfillment of the 1941 university credo
"To earn a living and live a cultured life
not as two processes but as one."*

CONTENTS

ACKNOWLEDGMENTS

We would like to thank chancellor John Christensen and Nancy Belck for their support and encouragement; Jim Leslie, B.A. (1963) and Tony Flott, B.A., M.A. (1990 and 1999, respectively) at the alumni association; Steve Shorb, dean of the library; Tim Kaldahl, B.S., M.A. (1990 and 1999, respectively); Wade Robinson; Matt Tilford, B.G.S. (bachelor of general studies, 1987); Claude Thomson Jr. at Institutional Research; Gayle Peterson; and the always supportive dean of arts and sciences, Shelton E. Hendricks.

The following provided, suggested, or identified photographs that contributed to this cavalcade: Joseph S. Brown; Michael Carroll; Jerry Cederblom; Judy Doyle; Tim Fitzgerald; Dr. Karen Garver, M.S. (1981); Jeremy Lipschitz; David Low; Bonnie O'Connell; Tammi Owens; Sharen Rotolo, B.G.S., M.A. (1996 and 2001, respectively); Cynthia Taylor; Jim Veiga, B.G.S. (1991); Cathy Young; and David G. Hicks, B.A. (1979). Our colleagues in the history department who shared memories include Maria Arbalaez; Harl Dalstrom, B.A., M.A. (1958 and 1959, respectively); Bruce Garver; Bill Pratt; and Michael Tate. Ann Marie Lonsdale and John Pearson at Arcadia Publishing always provided encouragement.

Kenny Rosen of Sir Winston Ltd. allowed access to his collection of Ak-Sar-Ben memorabilia. Dottie Rosenblum and Kathy Weiner at the Nebraska Jewish Historical Society, the Douglas County Historical Society, the Nebraska State Historical Society, the Charles and Mary Martin Fund, and Dr. John and Gloria Barton provided support for the preparation of these photographs for publication.

Tommy Thompson's groundbreaking work, *A History of the University of Nebraska at Omaha, 1908–1983*, published in 1983 as part of the observance of the 75th anniversary of the school, is indispensable to the study and understanding of our institution. Over 20 years have passed since Professor Thompson's work appeared, and during the interim, the richness of archival resources has substantially expanded. Les Valentine has served as university archivist since 1986, overseeing the repository of the university records and over 75,000 photographs. The coauthors have in excess of 60 years at the University of Nebraska at Omaha. We continue to find new information about the past. The archive is making quantum leaps in acquisitions and accessibility. For example, it now contains the over 18 linear feet of speeches by Ronald Roskens and Del Weber starting in 1960. We have taken a fairly strict chronological organization. Our theme is the cavalcade of university life moving between the mundane, high, and low spots.

We hope our contribution furthers understanding of the place of our campus in the culture of American higher education and assists Deborah Smith Howell and Kevin Naylor, cochairs of the Centennial Planning Committee, to celebrate the 100-year evolution of the university that will occupy 2008–2009. All photographs are from the University of Nebraska at Omaha Archives.

INTRODUCTION

Education in America, always prized, spread like many amenities from elites to the wider population and became a necessity. Communities and individuals place their faith in college to provide a transformative experience. It is not a panacea, nor is success guaranteed. Sometimes colleges are geographically ill placed. Sometimes students enroll who would have been better advised to take a different educational path. Higher education in America is a growth industry beset with business cycles. Balancing budgets and creating an appropriate fit between the intake of new students and prospects for graduation are ever in the forefront of administrators' minds.

Nebraska has seen many paper colleges in paper towns as well as the failure of many start-up colleges. About 50 Nebraska colleges have closed their doors or lost their identities in merger. Lacking the right mix of students, faculty, administration, financial support, and demographic mass could lead to a short-lived venture. It helped to be located in a county seat, to be on the railroad line, and to have a committed benefactor. Creating a university posed numerous challenges.

Omaha University and the University of Nebraska at Omaha provided opportunities for students to complete their education in an atmosphere where employment, family, and financial considerations made attendance at Creighton University or the University of Nebraska in Lincoln impractical. The early graduates quickly turned their education down life-transforming paths. Alumni served as ministers, served as military officers, taught at all levels of education, operated businesses, became lawyers and doctors, and generally contributed to the diversity of American life.

While students at four-year residential campuses are typically kept on track to graduate in four years, student enrollment at an urban commuter campus, or hometown school, typically suffered severe attrition and the substantial extension of the normal four-year education. Many of Omaha University's graduates were students returning to college. Never did the faculty waiver on the need to challenge students. Education raises the sights of students and eschews the lowest common denominator.

Approaching 100 years of existence is an appropriate time to assess continuity and change and the role of the institution in the lives of students, teachers, and the community. Providing a liberal education and an arts and science core, and exposing students to the wide spectrum of culture and intellectual possibilities has been a constant. This commitment underwent periodic remodeling as the needs and interests of business, technology, and social consciousness dictated. Greek, Latin, and Bible instruction declined. The education in majors, minors and electives, business education, and a practical curriculum superseded the classical education. Relevancy ushered in during the turbulent 1960s appeared just as the computer inaugurated the electronic information age. By the end of the century, rapidly developing cybertechnology reshaped the campus as the College of Information Science and Technology emerged on the south campus.

As the university grew in size and complexity, departments and colleges would break off from the College of Arts and Sciences, usually for administrative or budgetary reasons rather than intellectual reasons. Thus, within the last 30 years the College of Fine Arts separated from

the College of Arts and Sciences and most recently, in 2005, the School of Communications, comprising broadcasting, journalism, and speech, relocated to the College of Communications, Fine Arts and Media. Yet in 2006, the enrollment in the College of Arts and Sciences exceeded what it had been when it contained the Department of Communications. Similarly, as enrollment grew, the constituent departments of the College of Arts and Sciences were relocated into new and separate buildings. Thus, arts and sciences instruction occurs in the original 1938 building, in Allwine Hall built in 1970, and since 1987 in the Durham Science Center.

The college experience extends beyond classroom instruction. Sports and music, passions among the young, find their place in university life as competitive, participatory, and spectator exercises. Debate, drama, journalism, spiritual life, socialization at dances, and community service fill the annual school calendar.

Leadership in the university involves presidents and chancellors, vice chancellors, deans, and department chairs. Names and functions change with the times, hence the demise of the dean of men and the dean of women. Personnel became Human Resources. Administrators at their best provide leadership and moral and financial support. Communication is sometimes strained by posturing, rumor, and disinformation, especially during periodic budget crunches when projected revenue shortfalls require financial stringency and cutbacks.

Presidencies and chancellorships may be marked as placid or stormy, determined by how they ended. University presidents Daniel Edwards Jenkins, Ernest Wesley Emery, Rowland Haynes, Philip Milo Bail, and Kirk E. Naylor, and chancellors John Victor Blackwell, Ronald Roskens, and Del D. Weber would be characterized as actively placid. The end of the Karl F. Wettstone, William E. Sealock, Leland E. Traywick, and Nancy Belck administrations would be stormy and generally reflect tension between the university administration and local business interests.

Since 1938, the university has expanded from 20 acres to 77.6 acres on the north campus and 154 acres on the south campus. From 1969 to 1990, the university moved westerly into an old upscale neighborhood. Most recently the demise of the University of Nebraska at Omaha's longtime southern neighbor, Ak-Sar-Ben racetrack, has introduced the prospect of expansion toward the south, across Pacific Street and toward Center Street. Rising enrollment, expanding faculty, up-to-date pedagogy, and the need for special state-of-the-art academic resources necessitates new laboratories, "smart classrooms," playing fields, and an inviting modern atmosphere for students. The university is a center of creativity. Of approximately a dozen brick, mortar, and glass instructional facilities, the arts and sciences and fine arts buildings, Durham Science Center, information science and technology, and the library have signature art installations. The university, an aspiring community, has multiple academic, environmental, and cultural opportunities for continuous growth and creativity.

One

FOUNDERS AND FUNDERS
1908–1931

In the articles of incorporation, signed on October 8, 1908, establishing the University of Omaha, the founders declared their goal to establish "a university for the promotion of sound learning and education . . . under such influence as will lead to the highest type of Christian character and citizenship, with the Bible as the supreme authority." From the founding to its transformation into a secular municipal university in 1931, Omaha University (OU) had a veiled Presbyterian atmosphere, thereby providing an alternative to the Jesuit-endowed Creighton University or the state university in Lincoln. The title page of the annual catalog contained a statement by Pres. Daniel Edwards Jenkins: "Wisdom, like the Tabernacle of old, must dwell in the midst of the people." Despite the avowed Christian atmosphere that included daily chapel or convocation, a number of Jews and nonreligious students attended and graduated.

About 26 students started their studies on September 14, 1909. The school relied on the donations of land and cash by benefactors, and student tuition. No public funds were available. The start-up university on Omaha's north side economized on staff salaries and library development, resulting in a well-meaning teaching faculty who did not have the terminal degree, a doctorate. The library suffered from benign neglect.

The Redick mansion dating from the 1870s was transformed into an educational facility. Redick Hall was joined in 1910 by a gymnasium that besides being an athletic and sports center hosted receptions, graduations, and dances. As an auditorium, it seated about 1,000 people.

The close-knit student body produced an invaluable newspaper and annual, founded fraternities and sororities, and participated in sports, dances, drama, debate, and college pageants. The students brought renown to themselves and the university. Harry Jerome (OU, 1912) married his college sweetheart, the first gala queen, Gladys Solomon (OU, 1913), and earned his doctorate at the University of Wisconsin where he taught and chaired the economics department until his death in 1938. The alumni association, established in 1913, welcomed 13 female and 7 male new graduates in 1915.

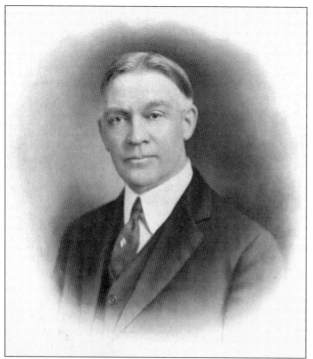

Daniel Edwards Jenkins, born in North Wales in 1866, attended the Universities of Wooster and Melbourne, in Ohio and Australia. Returning to America in 1890, he attended Princeton Theological Seminary. Ordained in the Presbyterian ministry in 1891, he served as president of Parsons College in Fairfield, Iowa. In 1900, he accepted the chair of doctrinal theology and apologetics at Omaha's Presbyterian Theological Seminary. He served as the president of University of Omaha from 1909 until his death in 1927.

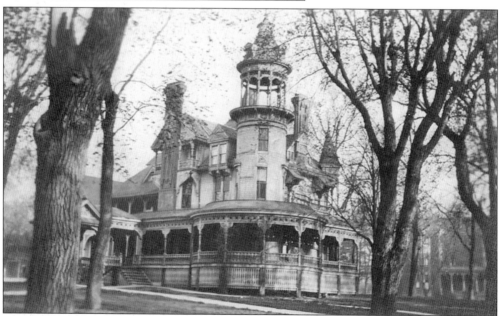

Redick Hall, dating from the mid-1870s, is named for Oak C. Redick, a member of the board of trustees who offered his 10-acre homestead mansion at Twenty-fourth and Pratt Streets on flexible terms. Remodeling the grand mansion involved turning bedrooms into classrooms, laboratories, a chapel, and space for students and faculty to eat and socialize. The kitchen housed physics, the garage chemistry. The completion of Joslyn Hall in 1916 relegated the mansion obsolete. It was dismantled and shipped 222 miles to Currie, Minnesota, and recycled as a dance pavilion and café on Lake Shetek.

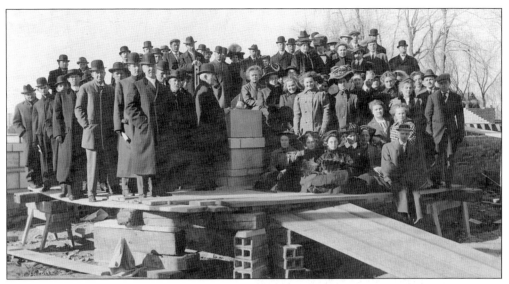

John G. Jacobs Memorial Gymnasium, erected in 1910, is named in memory of the deceased son of the benefactor Lillian Maul, who donated the land upon which the structure stood. Among the guests were Rev. J. S. Ebersole, W. T. Graham, Dr. H. H. Maynard, Rev. F. T. Rouse, Judge Howard Kennedy, Isaac Carpenter, and Rev. Julius S. Schwartz. Some of the marble from the dismantled Douglas County Courthouse went into this structure. When torn down in 1964 to make way for the Omaha Housing Authority home for the aged, the cornerstone box revealed a list of faculty and employees, newspapers of the day, university fact sheets, and articles of incorporation.

The May Party in spring 1912 became a regular feature of campus life for many years. The press reported that Lucile Hager entertained female students on Saturday afternoon in her home. They spent the afternoon appreciating personalized delicate handmade invitations, making paper flowers, and playing games. The dining room, decorated in yellow and green, featured a huge bouquet of daisies and ferns at the center of the table.

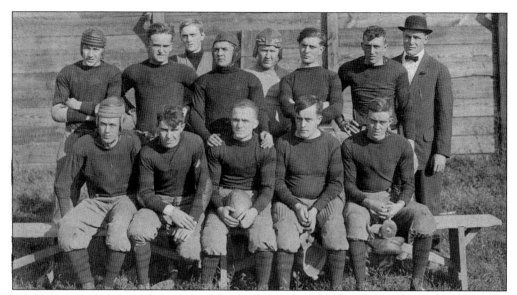

Coach Otis Morganthaler and the OU football team are shown in the fall of 1913. The press reported the "girls are bubbling over with enthusiasm" to prepare a banquet for the football team. Pres. Daniel Edwards Jenkins toasted the team for its "stick-to-itive-ness," which "counted more than the score." Captain Paul Selby toasted the faculty. Edna F. Sweeley quoted a South Dakota coach who observed the OU team for three years "and felt sure that the spirit they showed on the field was but the foundation for a strong team within a couple of years and would also bring about a strong university." Morganthaler left OU with a record of two wins and four losses.

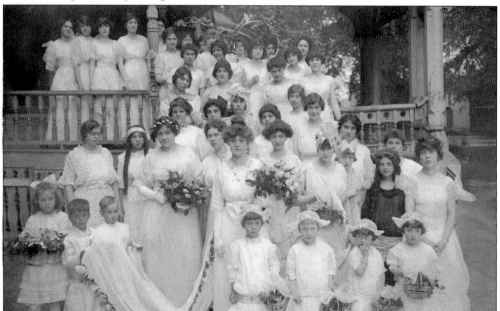

Shown here is Mildred Foster, Gala Day queen of May 1914. Springtime and the lengthening sunlight hours evoked celebration. May Day turned into an athletic department fund-raiser. Each vote for the May queen cost a penny. Other activities included skits, a ladies' minstrel show, and a maypole dance. Gala Day fell from favor in 1934 when the administration disapproved the musical satire "Pass the Bucks," dealing with the failure to obtain federal funds for new buildings.

Edna F. Sweeley, professor of French and literature, is seen posing in 1913 between Jacobs Gymnasium and Redick Hall. The 1911 catalog listed 12 classes in Greek, 11 in Latin, 12 in German, 8 in French, and 3 in Spanish. Other languages taught over the years included Hebrew, Italian, Swedish, Portuguese, Czech, Russian, Farsi, and Sanskrit. Student activities supporting foreign-language instruction included clubs and language trips to France, Mexico, Spain, and Germany.

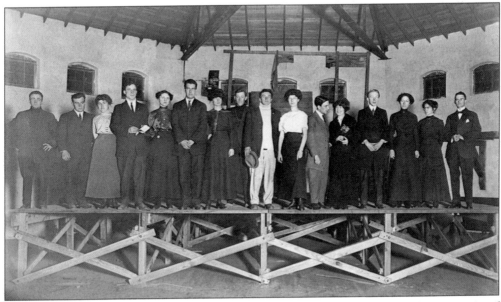

The senior class in 1913 performed *Hicks at College*. Originally performed at the University of Minnesota, the story focuses on Hiram Hicks, a millionaire breakfast food man who sounded like John Harvey Kellogg. The money raised by the first thespian production went to purchase a suitable memorial to the university, the first gift from the student body.

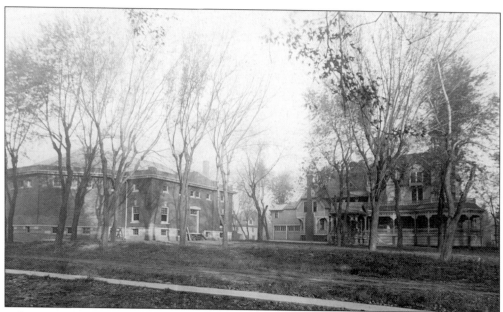

Before—how often do changes of the urban landscape go unnoticed and unremembered? When a new building goes up one does not remember what had previously occupied the space. This picture reveals Jacobs Gymnasium and Redick Hall.

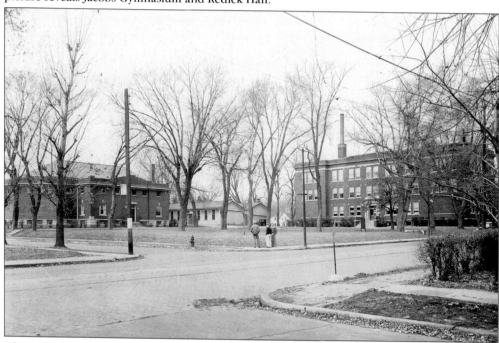

After—Jacobs Gymnasium and Joslyn Hall are shown at Twenty-fourth and Pratt Streets. George A. Joslyn and his Western Newspaper Union shipped boilerplate advertisements by rail to newspapers around the country. Joslyn donated $25,000 for a building contingent on the trustees raising additional funds. The three-story building with a basement, completed in 1916 with 30 classrooms, a chapel, college offices, laboratories, a library, and art rooms, replaced Redick Hall. Joslyn died in October, and the building opened in December 1916.

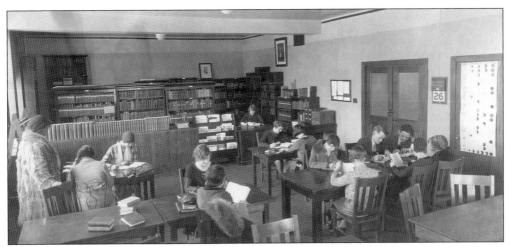

The characterization of the formation of the university as "without benefit of a library" (a play on Rudyard Kipling's short story *Without Benefit of Clergy*) may have been an overstatement. The Omaha Public Library, built in 1894 at Nineteenth and Harney Streets, supplemented the inadequate Joslyn Hall library. By 1928, the university library contained over 5,000 volumes. It moved into a separate temporary structure around 1930.

Religious organizations provided opportunities for socialization, as this 1913 YWCA stag party reveals. The YMCA and YWCA played a significant Protestant role on campus. About half the faculty were Presbyterians. Early campus plans contemplated separate YMCA and YWCA buildings. American religious diversity, typified as "Protestant, Catholic and Jew," provided the basis for social services to American troops during World War I through the YMCA, Knights of Columbus, and Jewish Welfare Board, which were replaced by the United Service Organization (USO) in World War II.

The Medieval History Club in 1916 gave students the opportunity to learn outside the classroom. The faculty adviser, Henry W. Siebert, is on the far right. Extracurricular activities, initiation ceremonies, and field trips enriched the educational experience. Some clubs flourished for several years. In more recent years, students joined the Society for Medieval Anachronism.

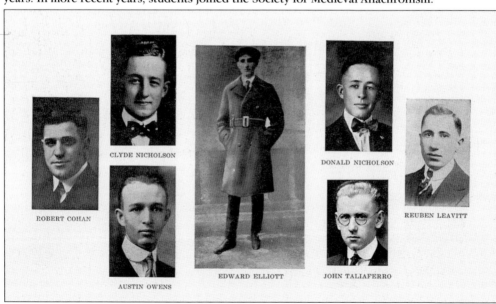

During World War I, enrollment dropped as students joined the service or worked in war industries. Team sports were cancelled for the duration of the war. The *Gateway* dedicated the 1918 volume "to the boys who have heard the call of their country and have taken arms in defense of humanity with that spirit of self-sacrifice which has led them to give up all that is most dear to them." The University of Nebraska and Creighton University, with more students and alumni in the war, counted 43 and 27 deaths, respectively.

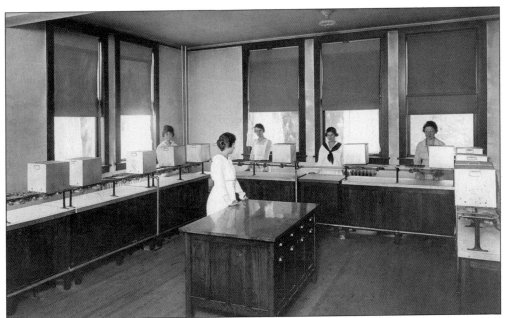

Domestic science class is seen in Joslyn Hall in 1920. Home economics included four classes in sewing and four classes in cooking, a prerequisite to taking the two classes in food and dietetics. Classes were offered in household accounts, interior decoration, and home management. The course in textiles studied fabrics with hands-on activities in simple loom weaving, basket weaving, embroidery, and crocheting.

The first debate with Bellevue College in 1909 considered the issue of the commission form of government. Roman L. Hruska, in the center, attended the University of Omaha for two years (1923–1925). He studied at the University of Chicago and earned his law degree at Creighton University. Hruska served on the Douglas County Board of Commissioners, in Congress, and in the U.S. Senate from 1954 to 1976. He served on the board of directors of the University of Omaha Alumni Association, 1946–1948, and in 1950 on the board of regents of the university. Hruska died in 1999. On the left is debate captain Joe Houston and on right, Morgan Myers.

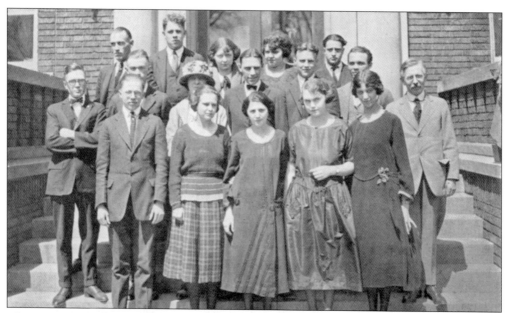

Albert Kuhn is pictured in the second row on the right with the German Club in 1923. Kuhn, born in Switzerland and educated at the University of Wisconsin and the University of Chicago, taught in Brooklyn and at Dubuque before arriving in Omaha. A Presbyterian minister, he started teaching German at OU in 1919. His repertoire included French, Latin, and history, and Greek at the seminary. Kuhn escorted students to Europe in the summer of 1930. The daughters of Professors Kuhn and Henry W. Siebert were OU students.

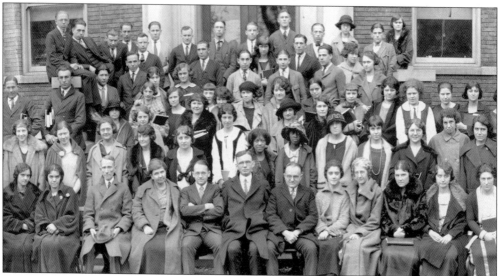

Some students and faculty on October 26, 1923, on the Joslyn Hall steps include, in the bottom row, Nell Ward (fourth from right), Thomas Earl Sullenger (sixth from right), Augusta Knight (fourth from left), and W. Gilbert James (third from left). Sullenger went to graduate school at the Universities of Oklahoma, Chicago, and Wisconsin and earned his doctorate at the University of Missouri. He taught sociology from 1923 to 1958, established the Bureau of Social Research, and published reports on urban problems encompassing immigrants, family structure, divorce, juvenile- and child-related issues, and mental illness.

The men's faculty and women's faculty buildings occupied former private residences. According to the 1936 *Tomahawk*, the men's building, "a noisy, but a nice place," contained the Gateway office, a lounge, and faculty offices on the second floor. The women's building had tea, luncheons, parties, club meetings, and snacks from the "kitchen cupboard to get one's tummy filled." A "convenient place to study or talk . . . every co-ed has a warm feeling around the heart when she thinks of the services this building has rendered her."

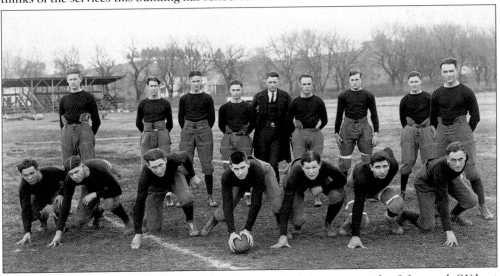

Coach Ernie Adams and the 1922 OU football team ended the season with a 2-3 record. OU beat Tabor and Western Union and lost to Trinity, Parson, and Tarkio. Sportswriter Howard S. Anderson reported in the *Gateway*, "In their game with Tarkio they made 17 first downs as compared to Tarkio's 3, and loses the game," 0-12, "only by the unfortunate breaks." Adams coached from 1920 to 1925 and had a record of 16 wins, 13 losses, and 2 ties. From left to right are (first row) Paul Konecky, Bill Flynn, Tex Pratt, Fletcher Slater, Alfred Kastman, David Chesneau, and Merrill Russell; (second row) Wilbur Erickson, Harold Ackerman, Edwin Willmarth, Leo Konecky, Adams, Charles Poucher, Glenn Hesler, Bill Christy, and Ben Shurtleff.

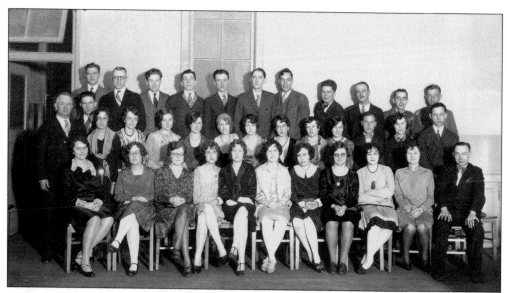

Alexander J. Dunlap and the College of Commerce Club are shown. Dunlap, a football player and hurdler at Hastings and the University of Nebraska, and a Central City attorney, came to Omaha in 1924 to serve as dean of the College of Commerce and Finance and as athletic director, coaching golf and introducing track and baseball. Dunlap syndicated his verse with George A. Joslyn's Western Newspapers Union. He helped draft the legislation creating a municipal university. He died in 1932 at the age of 51 of heart disease while on a fishing trip in northern Minnesota.

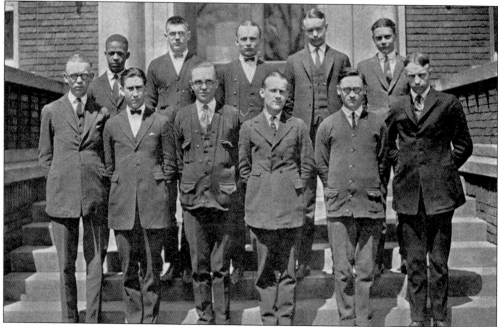

The men's glee club, established in 1922, performed on and off campus. Music is a constant feature of student life. Whether performing in the band, orchestra, choir, or glee club, listening to the gramophone or Victrola and its technological progeny, tapes, CDs, DVDs, Napster, or iPod, it provided entertainment, relaxation, and a pleasant background to serious endeavor. James Lewis (second row, far left), the glee club librarian, also played on the football team.

W. Gilbert James taught at Upper Iowa University, Bellevue College, and Highland College and came to OU in 1919. English and speech were his specialty, but he confided, "I smile to think of the number of subjects I have taught," including argumentation, logic, philosophy, American history, and sociology. He served as interim president during Dr. Daniel Edwards Jenkins's 1926–1927 leave of absence and again in 1928 following Pres. Karl F. Wettstone's resignation. In 1933, he headed the new school of fine arts until its abandonment in 1937. He retired and died at the age of 68 in 1948.

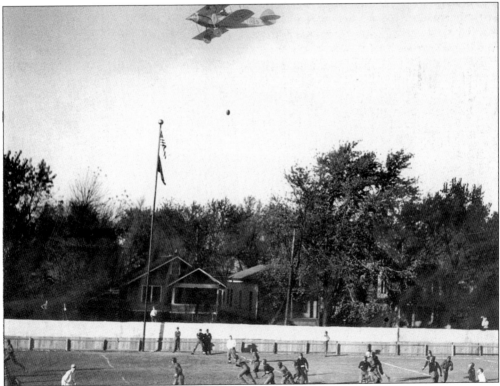

The Omaha Cardinals did not have a very good 1927 football season. Chadron Normal ran up the score to 117. On October 22, the Grand Island College Zebras beat coach Lloyd M. Bradfield's squad 20-0 at its new Omaha Uni field at Twenty-fourth Street and Ames Avenue. To commemorate the opening of the new field, the Overland Tire Company donated a ball that a low-flying airplane dropped at 2:30 p.m.

Karl F. Wettstone succeeded interim president W. Gilbert James in 1927. He became president of the University of Dubuque in 1924 at the age of 29. He had gone to the academy at Dubuque, been its valedictorian in 1913, and graduated in the 1916 seminary class. He wanted to raise academic standards. Wettstone's tenure falls into the stormy category. The students hung him in effigy for his role in enforcing grade standards and setting aside a student election that interfered with athletic eligibility.

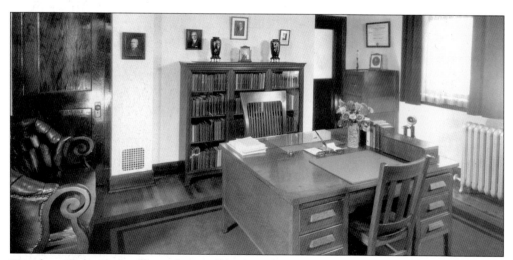

President Wettstone's office, photographed in the trompe l'oeil genre, included a double partners desk, ornate couch, bookcases, vases, telephone, flowers, and pen stand and reflected a tranquil, sophisticated order. The wall pictures include Pres. Daniel Edwards Jenkins and Wettstone's diploma.

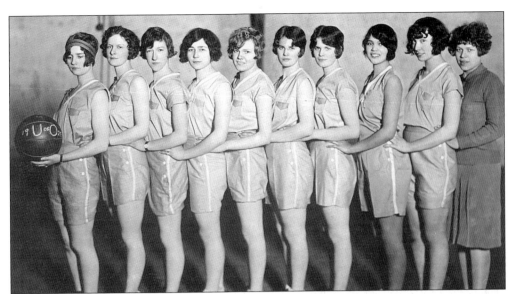

The 1927–1928 women's basketball team is pictured here. From left to right are Serena Morgan; Leah Daubenheyer; Mary Thomas; Corinne Jensen (captain); Linda Bradway; the Grace twins, Merle and Mildred; Madeline Shipman; Happy Cathers; and their coach, Hilma Peterson. Peterson, who taught mathematics, had played basketball as a student in the early 1920s and facilitated the controversial change of uniforms from bloomers to jerseys and shorts. They won 12 games and lost 1. The scores were remarkably lopsided, including a 54-0 victory over Brandeis, and a 57-7 win over Immanuel Baptist. They lost one game to the K. C. Caysees 24-33.

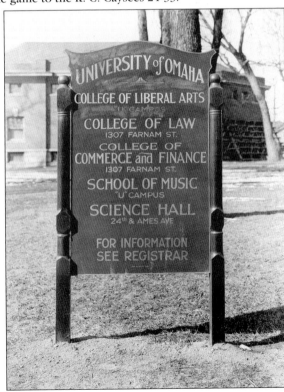

The sign welcomes and directs students and the public at the close of the first phase of the university's existence.

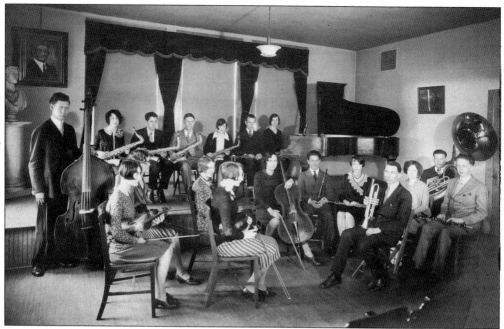

The school of music or conservatory actively supported an orchestra and band during the 1920s. Joslyn Hall housed classrooms, a library, a cafeteria, a bookstore, three practice studios on the third floor, and a 150-seat auditorium. Many of the students took music as part of their teacher education program.

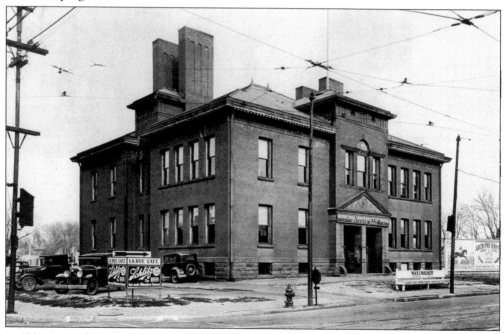

In 1927, Dr. Karl F. Wettstone reported that rising enrollment necessitated additional classroom facilities. The university leased the old Saratoga School at Twenty-fourth Street and Ames Avenue to serve as the science hall. Note the various billboards and the streetcar tracks in the foreground.

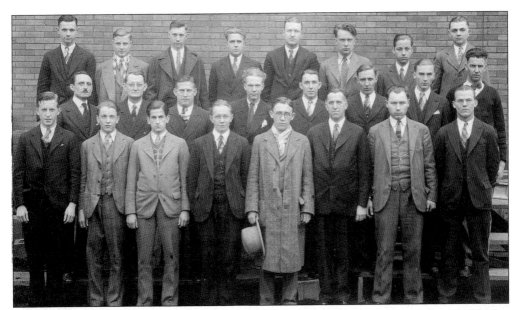

Pres. Ernest Wesley Emery and the 1930 YMCA Club are shown here. Born on a farm in Sedalia, Missouri, Emery worked his way through school. The United Brethren Church ordained him in 1915. Emery, an accomplished athlete in football, track, and basketball, came to OU after being athletic director at Indiana Central College and spending four years as president of York College. Emery wanted to find a new location and building and secure accreditation by the North Central Association. He is pictured at the bottom, third from the right.

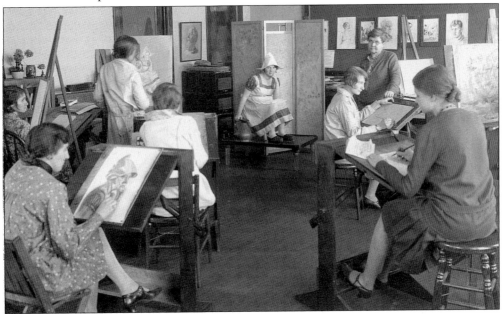

Augusta Knight arrived at OU in the early 1920s to teach art. The 1929 catalog states, "Art is not a luxury." Emulating William Morris, it states further, "Today the world demands beauty in its industrial creations as well as in its Art Galleries." The catalog lists 67 classes, including Saturday classes for teachers. The Paint Pot art club, composed of former art department members, "contributed in various ways to the equipment of the department."

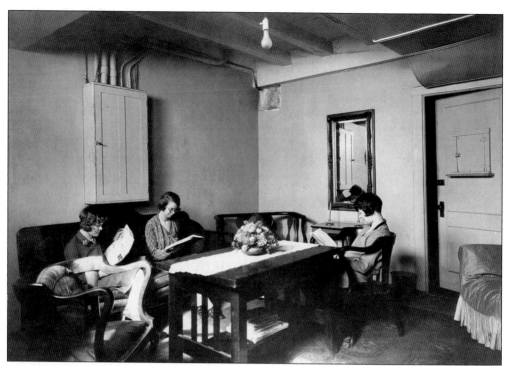

A mission table with runner and flowers, carpeting, and stuffed furniture graced the YWCA reading room in the Joslyn Hall basement in 1928, in an otherwise bleak semifinished room, complete with a bare hanging lightbulb and the electricity breaker box.

Pres. Ernest Wesley Emery introduced Senior Recognition Day in Jacobs Gymnasium on March 6, 1929. The formal daylong affair ended with Emery's inspiring speech. Letha C. Grove reported in the yearbook that students "caught a vision of what life might be and it seemed each person present must go away with renewed spirit and determination to bring to a realization that vision. We cannot forget Dr. Emery's talk—we cannot forget Senior Day."

Prof. Nell Ward (third from left) earned her bachelor of science and master of science at the University of Nebraska. She came to OU in 1917. She earned her doctorate in 1939 at the University of Iowa with a dissertation titled "The Photometric Determination of Cobalt and Manganese," chaired the chemistry department, and established the chemistry fraternity Gamma Pi Sigma, which later affiliated with a national group sponsored by the American Chemical Society. She retired in 1955 and married at the age of 69.

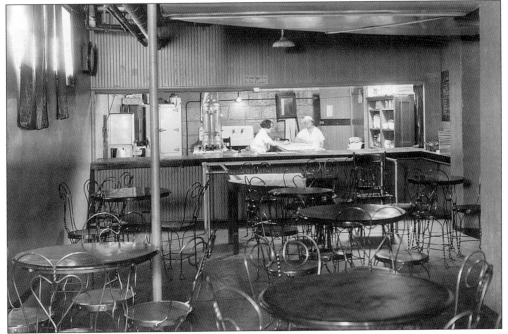

Students and staff needing a meal or snack went to the Joslyn Hall cafeteria. The building housed the bookstore, servicing student needs for books, pencils, pens, ink, paper, erasers, and miscellaneous learning accoutrements. Other than assigned books, much of this could be purchased at five-and-dime stores like Woolworth's and Ben Franklin.

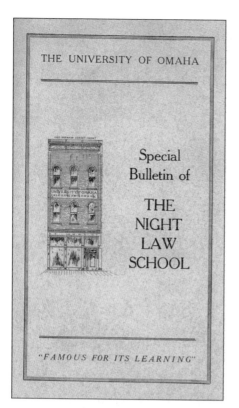

THE UNIVERSITY OF OMAHA

Special
Bulletin of

THE
NIGHT
LAW
SCHOOL

"FAMOUS FOR ITS LEARNING"

The opening of a four-year night law school in 1893 reflected the need of locally trained legal professionals. Creighton College of Law, opened in 1904, featured a night program from 1909 to the mid-1920s. Annual bulletins informed prospective students of admission requirements, faculty, and curriculum. The Omaha law school used local practitioners and judges as teachers. It merged with the University of Omaha in 1910.

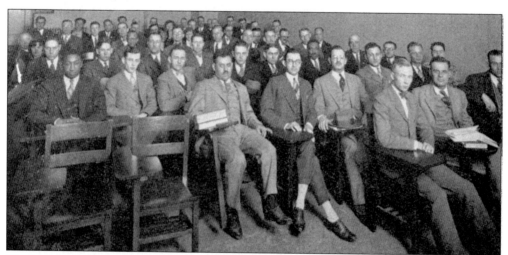

The law school provided education to those who worked during the day as well as to women and African Americans. The student law fraternity Lambda Phi met regularly. Graduates Margaret Fischer and Frank Frost were prominent in Omaha legal circles. The law school separated from OU in 1932. The American Association of Law Schools and the American Bar Association opposed unaccredited night law schools. The Nebraska Supreme Court ruled that OU law school graduates were ineligible to take the bar examination.

The University of Omaha Bulletin

VOL. 1 June 1, 1929 No. 6

General Catalog

Published Monthly by the Administration
of the
UNIVERSITY OF OMAHA
Omaha, Nebraska

Entered as Second Class matter, May 13, 1924, at the Post Office, at Omaha, Nebr., under the act of August 24, 1912. Accepted for mailing at the special rate of postage provided in Section 1103, Act of October 3, 1927, authorized May 13, 1924.

Colleges catalogs and bulletins describing the school to attract and guide students in their course of study are an invaluable official source for identifying staff, curriculum, and student life. In the last year of the private school's existence, the catalog expanded from 56 pages in 1928 to 132 pages in 1929. The 1932 evaluation team criticized the 1929 catalog as inflated. Municipal reorganization involved strategic contraction, and the catalog settled back to 53 pages in 1931–1932.

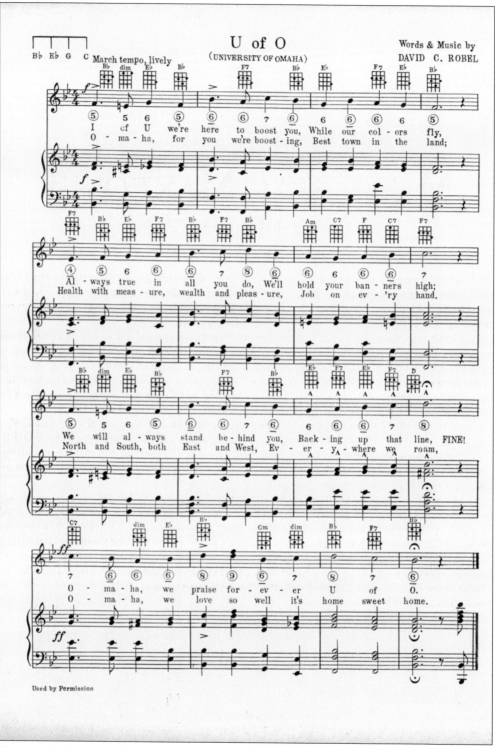

Shown is the sheet music for the school song, words and music composed by David C. Robel, a music student, in 1922. The music sold for a quarter; royalties benefited the Athletic Association.

Two

MUNICIPAL MAKEOVER
1931–1937

Declining support from the religious faithful and the Depression placed the existence of OU in peril. Several colleges and universities across the nation closed their doors. OU sought assistance from the local community and by a close vote of the citizenry became a municipal university reliant on local tax revenues.

The 1932 external assessment indicated weaknesses and strengths and outlined minimum requirements for OU to obtain the vitally coveted accreditation. Reorganization, the infusion of faculty with terminal academic degrees, the attrition of less-qualified faculty, the dedication to improve library facilities, the application for federal assistance, and the search for a new location, all occurring within the space of a half dozen years, during an economic depression, proved a heady task for any university president and the governing body of regents.

Pres. William E. Sealock recruited faculty from the Universities of Wisconsin, Ohio, and Nebraska. Edgar Holt, from Ohio, chaired the history department and as dean introduced a general education requirement for the natural sciences, arts, and humanities based on the curriculum at the University of Chicago. Some things were held in abeyance; no student annual appeared from 1930 to 1935.

Some regents resented Pres. Franklin D. Roosevelt's New Deal and Tennessee Valley Authority public power legislation supported by Nebraska senator George Norris. The regents removed President Sealock, who they perceived as too liberal. Dean Edgar Holt and regent Paul L. Martin, the former dean of Creighton University School of Law, raised issues about the violation of academic freedom. Martin resigned in protest. The disappointed Sealock committed suicide. Rowland Haynes, a National Recovery Act coordinator, president from 1935 to 1948, superintended the school move in 1938 to the current campus and enrollment rise from 500 students in 1935 to more than 4,000 in 1948.

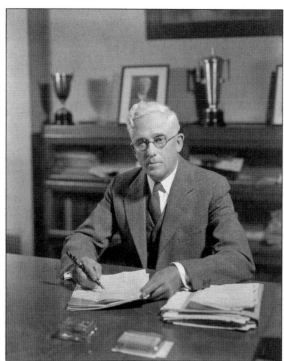

William E. Sealock earned his doctorate at Columbia University. His experience at the University of Iowa and the University of Nebraska Teachers College prepared him to accomplish the "makeover." Perhaps he moved too quickly, was too liberal, and as a Unitarian not sufficiently "Christian" for the business community and lingering Presbyterian sensitivities. He became a lightning rod in a clash between the New Deal and vested economic interests. The regents did not renew his contract in 1935, and he committed suicide a few days later.

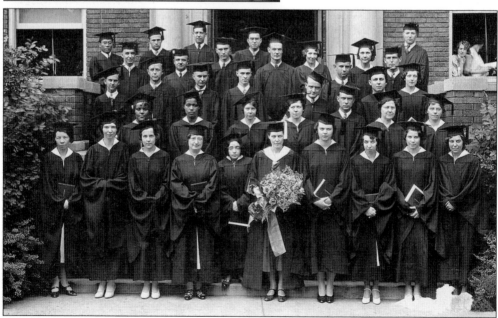

Rabbi Frederick Cohn of Temple Israel delivered the invocation for the class of 1932. Dr. George F. Arps, dean of the College of Education of Ohio University, gave a somewhat glum commencement address. Prizes totaling $35 were awarded to three students for their academic performance by the Isaac Sadler Chapter of the Daughters of the American Revolution for history, the Harry Jerome prize for economics, and Alpha Kappa Delta for sociology. President Sealock, just released from the hospital, awarded degrees to 48 graduates, about two-fifths of whom were women. Rev. Bryant Howe of Grace Methodist Church delivered the benediction.

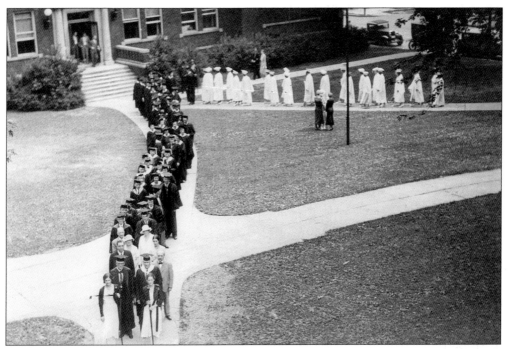

The traditional graduation class procession in 1932 is led by President Sealock and two torchbearers with Joslyn Hall in the background. They marched twice around campus before entering Jacobs Gymnasium.

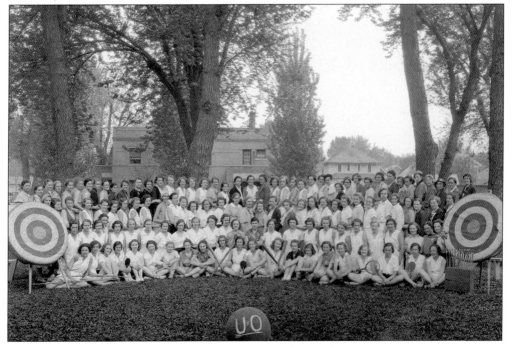

The Women's Recreation Association poses in athletic clothing for a group picture. Bows, arrows, archery targets, baseball bats, tennis racquets, and table tennis paddles symbolize the various sports. The ball in the foreground is either a medicine ball or a basketball.

The municipal university Cardinals, donning the scarlet and black colors, won all nine conference games to earn the Nebraska Intercollegiate Athletic Association championship. Their championship season included 20 victories. They defeated York, Chadron, Wayne, Cotner, Nebraska Wesleyan, Kearney, Hastings, and Peru. OU played at Benson High School. Pictured are, from left to right, Lowell Curtis, Lloyd Paterson, Reign Byers, Benny Huff, Max Egbert, George Hartman, Carroll Sales (captain), Bob Hegarty, Robert Brown, Marlin Wilkerson, and coach Sed Hartman, who coached from 1931 to 1942 with a football record of 39 wins and 41 losses.

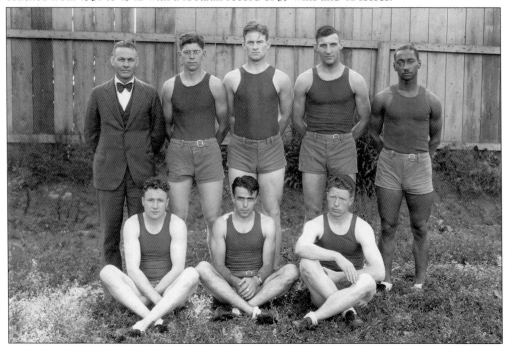

Coach Sed Hartman is shown with the 1932 OU track team.

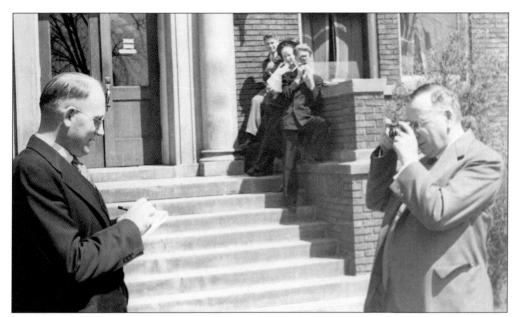

A student takes a picture of Pres. Rowland Haynes, on the right taking a picture of dean of men Lloyd M. Bradfield, professor of history and psychology, in front of Joslyn Hall. Haynes, a Phi Beta Kappa graduate of Williams College, served as the New Deal National Recovery Act coordinator in Nebraska and secretary of the University of Chicago. The board of regents offered him the presidency of the university in 1935. Haynes served until 1948 and died in 1963.

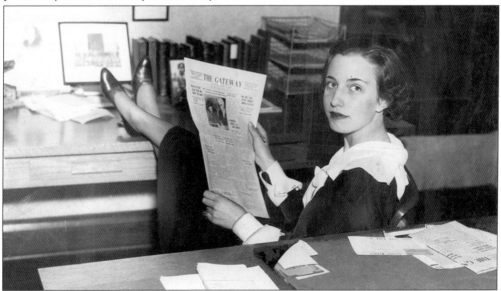

Ellen Hartman, a 19-year-old sophomore, edited the *Gateway* in 1935. Prof. Royce West headed the University Board of Publications. The May 17, 1935, *Gateway* stated, "She was opposed to the tendency among college editors to join radical movements and said she would steer the Gateway clear of such entanglements during her term." Ellen Hartman Gast (1938), a social studies teacher at Northwest High School, served as vice president of the alumni association in 1970, president in 1971–1972, a member of the board in 1974, edited the association's newspaper and newsletter, and helped found the University of Nebraska at Omaha (UNO) Alumni Century Club.

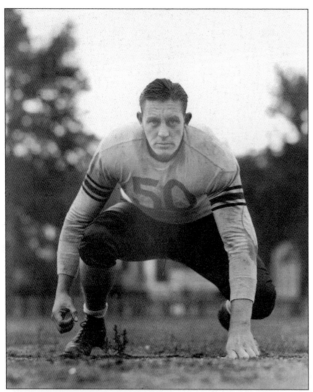

Gerald Gardner, a 20-year-old six-foot-two-inch, 215-pound tackle, was the largest member of the 21-player 1936 squad coached by Sed Hartman. Nine players came from Omaha, two from Lincoln, Council Bluffs, and Malvern, and one each from Bloomfield and Wahoo, Nebraska, and Walnut, Fort Dodge, Red Oak, and Shenandoah, Iowa. They defeated Morningside and Wayne State College, tied South Dakota State and Iowa Teachers, and lost to North Dakota State, South Dakota, and DePaul University, the latter by 46-0.

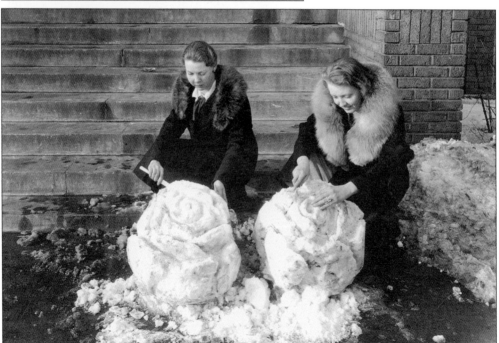

Despite the cold, carving snow roses near the Joslyn Hall steps was a hands-on, gloves-off procedure. Agneta E. Jensen, on the left, an accomplished artist, prepared the artwork for the 1936 *Tomahawk*.

Shown is a slow dance in Jacobs Gymnasium in the 1930s. Through the eyes of the photographer, one sees a live band of brass, strings, and piano, and period letter sweaters, hairstyles, and clothing.

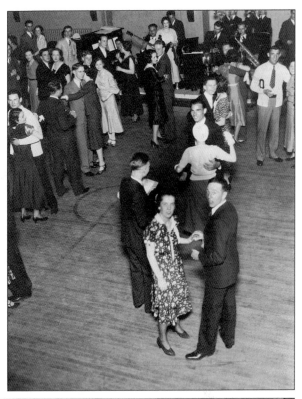

Professor of education Leslie O. Taylor and the members of Sigma Phi, an honorary fraternity for future teachers, pose in front of Joslyn Hall in 1936–1937. Student officers were Bess Greer Shoecraft, president; Marjorie Williams, vice president; Betty Minteer, secretary; Francis Johnson, treasurer; and Janis Johnston and Anna Goodbinder, sergeants at arms. About half the students in this picture graduated in 1937. Faculty sponsors included Frances Wood, Elizabeth Kaho, and Dr. Taylor.

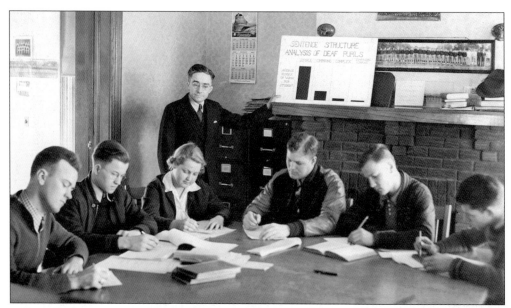

William H. Thompson, a professor of psychology, is in the classroom discussing sentence structure analysis of deaf children. Thompson graduated from OU in 1917. He earned his doctorate in psychology at Ohio State University and returned to OU in 1931 as athletic director and head of the psychology department, dean of men, and dean of arts and sciences from 1942 to 1960. An outspoken figure, he retired in 1965 and died in 1981, and the Alumni Center took his name in 1981, shortly after his death.

Prof. W. Gilbert James advised the drama club. During the 1936–1937 school year, it met monthly and performed *Undercurrents*, *The Toy Heart*, *Harmony*, and *Their Husbands*. Pictured here are, incompletely identified primarily by last names, Davis, Medlock, Pike, Middlekauff, Benson, Fred Plette, Mills, Thompson, Mickna, Dr. James, George Stearns, Lohrman, Mashek, Cisar, Johnson, Campbell, Burnett, Hurlburt, Anderson, Larsen, Amy Rohacek, Anderson, Bess Greer Shoecraft, Betty Arnold, Jane Vincent, Phyllis Bauman, Silverman, Jean Jarmin, and Eola Lieben.

38

Sigma Tau Delta, the national English fraternity for English majors, provided programs for novels, plays, and poetry. Eola Lieben was the president during the 1937–1938 school year. Social activities included a Christmas tea at the home of English teacher Laura Johnson and a spring banquet. Dr. A. Dale Wallace sponsored the group, and Ruth Behrmann served as the program chair. Original poems and short stories were published monthly in *The Little Grub,* edited by Ruth Thompson.

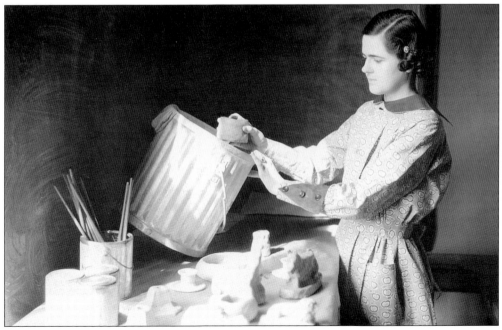

An unknown photographer took this 1937 photograph of cleaning up in art class as part of a National Youth Administration (NYA) project. The NYA, a New Deal program, helped students continue their educations during the Depression by providing part-time jobs. As many as 700,000 students ages 16 to 25 enrolled.

The 1937 *Tomahawk* made pointed reference to the role of women on campus, including their service on the student council and the *Gateway* and Ruth Grenville's editing of the *Tomahawk*. As in high school, the yearbook provided students the opportunity to improve their skills in acquiring photographs, arranging layout, printing, and marketing the completed volume.

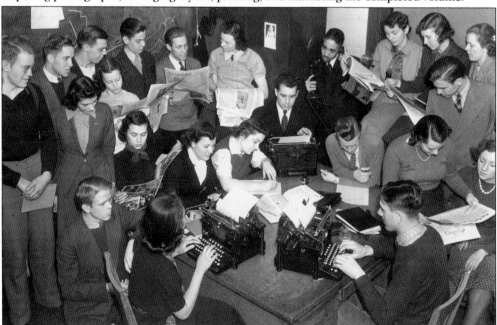

The *Gateway*, the published voice of the students, provided information on campus, student, and faculty activities, sports, and debated issues of the day. The slogan in 1937–1938 was "We use the news that's news to youse." Columns included "Keyhole," "Kaleidoscopia," "Betty Coed," "Roundabout," and "Mick's Diary." Editors usually served for a semester. April Fools' Day provided the occasion for a special edition, the *Gafoo*, which continues as a UNO tradition under various names, including the *Hateway*.

THE GATEWAY

VOL. 17 OMAHA, NEBRASKA, FRIDAY, OCTOBER 1, 1937 No. 1

109 Pledged To Greek Groups

One hundred and nine students were pledged to University of Omaha sororities and fraternities during the opening week of school.

PHI SIGMA PHI
Robert Claudius
George Rothe
Robert Clizbe
Edmund Barker
Arthur Johnson
Donald Zipper
Tom Fike
Robert Rapp
Edward Dulacki
Bob McAllister
George Threadgill
Walter Petersen
Kournis Peters
James Henry

THETA PHI DELTA
Meade Chamberlain
Charles Shoecraft
Vale Gamble
Dick Dodds
Bob Knapp
Austin Vickery
Ben Jenkins
Edward McNeill
Junior Covert
John Good
Don Harris
Norvin Ingram
Richard Nilsson
Charles Malec
Kenneth Lutes
Francis Chambers
Clark Knicely
Vincent Wiese
Roy Alley
Tom K. Davis

ALPHA SIGMA LAMBDA
Leon Lorensen
Bill Theisen
Allan Knoll
Claude Johnson
Howard Baker
Bob Norton
Paul Griffith
Donald Abrahams
Richard Cook
Franklin Thompson
LaVern Kritner
Fredrick Kroll
Roland Deaton
Harold McKenna
Grant Hobba
Everly McGrath
Drew Maxwell
Jack Powers
Phil Krogh
Leonard Nelson

ALPHA GAMMA CHI
Frieda Leibowitz
Adeline Tatleman

GAMMA SIGMA OMICRON
Doris Faldine
Claire Greenfield
Emily Thompson
Eleanor Jean White
Edith Wilcox

KAPPA PSI DELTA
Marie Fitzgibbons
Aggie Lou Hermea
Roseanne Hudson
Elizabeth Mayne
Cathryn Strohbehn

PHI DELTA PSI
Pauline Daugherty
Evelyn Delafield

CAMPUS IS BORN ON WEST DODGE

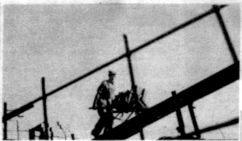

Men are laboring daily rushing construction of the buildings on the new University of Omaha campus. At left, a worker, framed behind a section of steel fabrication, hauls bricks towards one of the wings. Below, men stoop to lay the base for the steps. In the background, left, is a partial view of the east wing; to the right can be seen the steel beams which will support the auditorium roof.

New Campus Develops Fast

The Municipal University of Omaha's new campus has transformed during the summer months from a bundle of blue-prints into a huge framework of steel, brick, and cement.

A forceful reminder of the rapid progress made can be had from the following paragraphs taken from the last issue of last year's Gateway: "Board of Regents secretary, Dr. Floyd J. Murray, advertised in Omaha's dailies, Herald and Bee, for bids on general construction, heating and ventilating, plumbing and electric wiring. Tuesday, May 26, regents meet to receive bids. Will probably refer problems to building committee for study and compilation."

Since then, grading has been completed, foundations set, heating equipment installed, steel frame-work fabricated, and now the brick walls are already half completed on the second floor.

The structure is scheduled to be roofed by Thanksgiving Day,—just in time to escape the retarding effects of freezing.

In the heating system, no wall radiators are to be used. Fresh air drawn in through the cupola will be drawn into the basement, passed over heating coils filled with steam and transported to each room by a system of special ducts and blowers. The actual boilers and water tanks have already been installed, and the ductwork is going in as the walls are laid.

The WPA estimates that the entire project will be "substantially" finished sometime in February; however President Rowland W.

—Gateway Photo

New Professors Have Interesting Backgrounds

Earthquakes in Japan, working in a shipyard, research in speech and phonetics,—just some of the background of three professors new this year.

Dr. Dana T. Warren, assistant instructor of physics, received his training at Deerfield (Mass.) Academy and at Yale. While doing research work, he also taught at the latter school. Dr. Warren has spent thirteen years in Japan, teaching at Doshisha University in Kyoto for some time.

Much varied business experience has trained Wilbur T. Meek, who is taking Mr. Harry Severson's place this year in the economics department. Mr. Meek attended Omaha Central High School, received his B.A. degree from Princeton, and his M.A., at Columbia. He has taught at New York City College, St. Lawrence (N.Y.) University, and at Columbia. Among other places, he has worked for a shipyard, a newspaper office, the Western Electric Company, and has been employed by the government in business organization work.

Rositzke From Harvard

The English department has an

Activities Fee For Students Is Initiated

Beginning this year an incidental fee of three dollars each semester will be charged to all students in the University. In previous years the fee was just one dollar a semester but it did not include all of the privileges which will be granted this year.

Everyone will receive tickets of admission to all the games in football, basketball, and track. All student publications, the Gateway, weekly paper, Tomahawk, yearbook, and the Student Directory will be distributed to every student. This fee will also include tickets to Homecoming, which is November 13 this year, and Ma-ie Day which comes in the spring. It will be possible through this fund to bring outstanding speakers for convocations throughout the year.

Every student will be given a card which will be his pass to all of these activities.

Any surplus from these fees is to be used in promoting more intramural activities in sports. It is believed that by next spring, there may be some tennis courts completed near the new building and it is hoped that outdoor handball courts

The *Gateway* on October 1, 1937, announced the preparation of the new campus. From an educational perspective, the newspaper provided journalism majors practical experience.

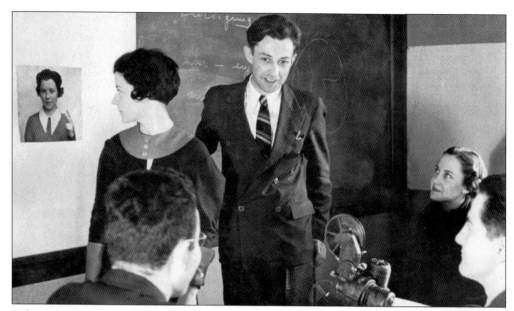

Debate competitions provided students the opportunity to travel and, hopefully, bring home prizes. Debate coaches emphasized research in current issues and arguing both sides of the question. Enid Crowder studies her poise and body language on eight-millimeter film. Dayton Heckman, professor of government, is to her left. In 1938, OU fielded seven teams, engaged in 94 debates, met 32 schools, and traveled over 3,500 miles. Seniors went to Bloomington, Indiana, to debate Illinois Wesleyan, DePaul University in Chicago, the University of Wisconsin, Beloit College in Wisconsin, and Iowa State. Five teams went to the state meet in Kearney. OU hosted Kearney, Midland, Hastings, and Brigham Young University.

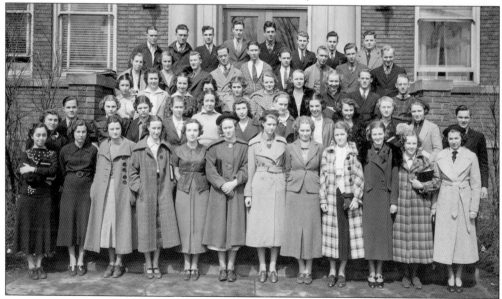

This photograph of about half the 1936–1937 freshman class, taken on the Joslyn Hall steps, includes, on the far left of the first row, Frances Blumkin, the daughter of Rose Blumkin, the matriarch of Nebraska Furniture Mart fame. A photograph of Frances appeared in a blanket toss in the May 24, 1937, issue of *Life* in a story titled "Omaha Undergraduates Do This."

The Ma-ie Day 1937 Princess Attira candidates, Betty Majors (winner, Sigma Chi Omicron), Amy Rohacek (Pi Omega Pi), Marian Benson (Barbs), and Ellen Forehead (Phi Delta Psi), are shown in this photograph from left to right. Votes were cast at the men's faculty building. Dress rehearsals were held at Peony Park, and the *Gateway* reported, "A faculty committee will be present for censorship purposes."

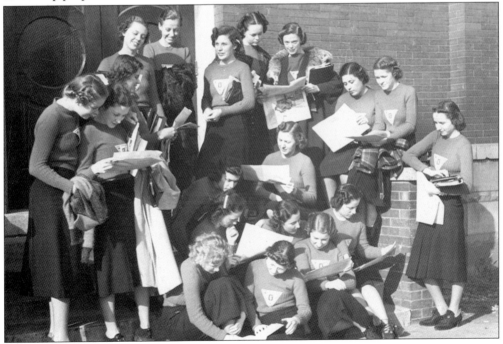

The Women's Athletic Association, wearing its distinctive sweaters, reads the mid-November 1937 *Gateway* in front of Jacobs Gymnasium. Social events included a Halloween initiation, dances, and skits.

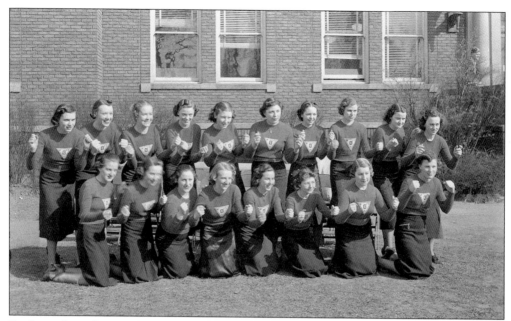

Feathers, the girls' pep club associated in 1938 with the national pep fraternity Phi Sigma Chi, held its 1938 national convention in Lincoln. The club had 25 members, three from each sorority and seven Barbs, short for Barbarians. Barbs referred to students and clubs that did not belong to Greek societies. The Barbs at Creighton, Lincoln, and other schools were sometimes a potent political force in campus elections.

Sarah H. Joslyn received an honorary doctor of letters degree at the June 1937 commencement. Her generosity assisted the university and helped establish the Joslyn Museum in 1931. The commencement speaker, Robert J. Kerner, professor of history at the University of California, Berkeley, a specialist in Bohemia who later published several works on eastern and central Europe, Yugoslavia, and Russia, received an honorary degree.

Three

WAR AND COLD WAR IN THE MUNICIPAL AGE
1938–1948

The drama of relocating the campus from downtown to west Omaha cannot be underestimated. Location and physical structure are critical to the effective delivery of education. The role of a new state-of-the art Georgian-style building, typical of 1930s university construction, partly funded by the federal government inspired culture and stability.

The administration building contained classrooms, laboratories, a library, administrative offices, faculty offices, a cafeteria, a nurse's clinic, a bookstore, an auditorium and gymnasium, maintenance space, and a boiler room. When administration moved to the Eppley Administration Building, it was renamed the Arts and Sciences Hall in 1981. Often remodeled in the late 1990s, the two-story auditorium space became classrooms and offices. Architectural remnants include a theater ticket office facade and the library dumbwaiter.

The university contains many memorials, cornerstones, bronze busts, and plaques commemorating the groundbreaking and dedication of buildings and the deeds of administrators. Buildings are named after donors and university officials. Graduating classes collect money and provide clocks, benches, and other memorabilia. No memorial is more poignant than the understated honor roll on the second floor of the arts and sciences building, a roster of 1,800 students, alumni, and faculty who served in the armed forces and Red Cross during World War II, 53 of whom gave their lives. Among the veterans were professors Paul Beck, Ruth Diamond, Dayton Heckman, Edgar Holt, and Lyman Harris, future bookstore manager Ben Koenig, and future regent Robert M. Spire, as well as Roy Valentine, the father of one of the authors.

The war disrupted staffing. Ruth Diamond went from teaching physical education and modern dance to the Red Cross. Women temporarily replaced men in several academic positions. The academic staff in 1939 numbered 59, of whom only 26 were still among the staff of 62 in 1949. The 10-person administrative staff in 1939 included one woman, associate dean Mary Padou Young. The 16-person staff in 1949 included Young and Alice C. Smith, registrar, as well as a head of veterans information service and director of vocational counseling and placement. The regents in both periods had one female member.

Despite the return to peace, the emergence of the cold war and the proximity of the university to Offutt Air Force Base, the location of the Strategic Air Command, positioned the campus to play an important role in providing postwar higher education to armed forces personnel.

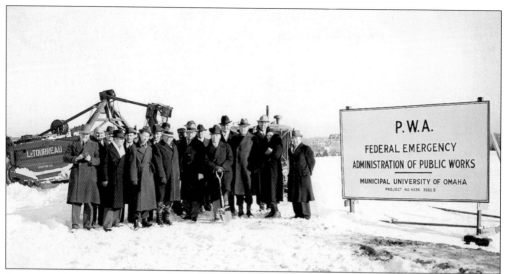

Snow contributed to a thinly attended groundbreaking for the administration building on Monday, January 11, 1937, accomplished at 2:15 "with a minimum of formality." F. T. Martin, chairman of the board of regents scooped up a shovelful of loose dirt. Harry A. Jacobberger, chairman of the grounds committee, and Pres. Rowland Haynes brought typed speeches and turned them over unread to be deposited in the school's archives.

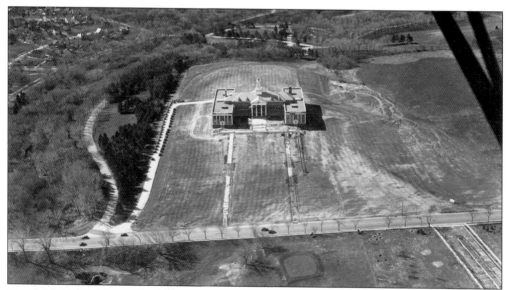

The New Deal Public Works Administration (PWA) provided federal funding for bridges, roads, courthouses, hospitals, and education facilities. Omaha received a federal grant and selected Sixtieth and Dodge Streets, the Elmwood Park neighborhood, for its new campus. Frank Latenser designed the air-conditioned building in the then popular Georgian style. Across Dodge Street is the Dundee Golf Course, successor to the Happy Hollow Golf Club, which since 1948 has been Memorial Park. Betty Ann Pitts wrote in the May 27, 1938, *Gateway*, "Though not built on a luxury scale, Omaha university's new building will not be without all the appliances, gadgets and thingumajigs which modern science has developed to make living more comfortable and attractive." In 1981, the administration building became Arts and Sciences Hall.

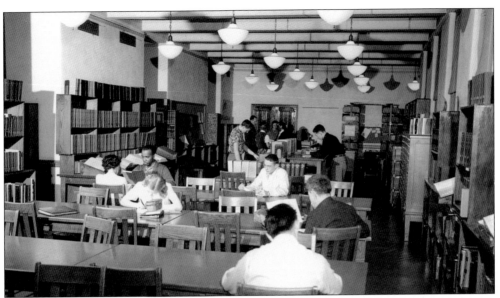

Study hall was in library room 220 in Arts and Sciences Hall. A dumbwaiter (that now serves as philosophy department storage space) connected the second floor west reading room to the closed book stacks one floor below. The 1940–1941 student handbook explains how the reserve books were checked out and that the waiting line to borrow reserve books at 4:00 p.m. formed immediately outside room 220. Jane Pope Geske, a student library worker who went to Denver for library school in 1943, later led the Nebraska Library Association.

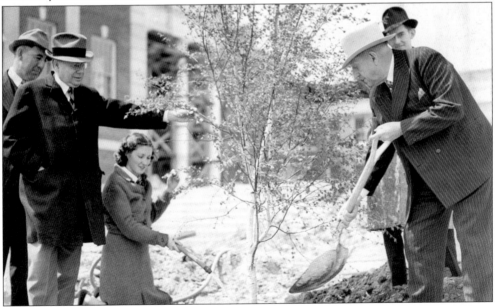

Arbor Day is Nebraska's contribution to national days of observance. Landscaping rehabilitates the scarred ecology of new construction, contributes to a green ambience, and maintains the campus within the greenbelt. On Arbor Day in 1938, OU administration, faculty, and a student pose for a photograph in front of the new building. From left to right are Frank Latenser, Rowland Haynes, Harriet Salmon (OU, 1939), D. E. Emmett Bradshaw (OU regent), and Edgar Howe (OU, 1938; student council president).

MARCH 31, 1939

UNIVERSITY ACCREDITED BY NORTH CENTRAL ASS'N

The University of Omaha was accepted to membership in the North Central Association of Colleges and Secondary Schools, an organization to maintain high standards of teaching, courses of study and physical equipment, according to word received late Thursday from the Association's annual meeting in Chicago.

Now that the University of Omaha is accredited by the Association, credits of students who transfer to other institutions for advanced professional training and graduate work will automatically be accepted on a par with all other universities and colleges that have received similar rating.

Before receiving accreditment from the Association the University of Omaha had rated individual accreditment from practically all members of the Association, including the University of Nebraska, the University of Iowa, the University of Chicago, and from such outstanding other institutions as Columbia University, Yale and Harvard, according to President Haynes.

The University of Omaha had previously been denied accreditment by the North Central Association because of inadequate facilities at its old campus on Twenty-fourth and Pratt streets. When the Association's inspectors visited the old plant a few years ago, a comment was made that the University "had the best faculty and worst buildings in the Middle West."

The Association's membership includes 231 universities and colleges in twenty states. Ten other Nebraska universities and colleges, besides the University of Omaha, are accredited by the Association.

The chief purposes of the Association in accrediting higher institutions are as follows:

1. To guide prospective students in the choice of an institution of higher education meeting their needs; and worthy of public recognition.
2. To serve universities and colleges in their relations with each other, such as the transfer of students, the conduct of intercollegiate student activities, the placement of college graduate and the selection of college faculties.
3. To stimulate through its accrediting practices the improvement of higher education in the territory of the North Central Association.

To be considered by the Association, an institution must be incorporated as a non-profit corporation devoted primarily to educational purposes, legally authorized to confer collegiate degrees and maintain high academic standards.

The University has expanded rapidly during the past year. Upon removal to the new campus and modern million-dollar plant, there has come an increase in enrollment of more than fifty per cent. The library has grown from a total of 20,000 volumes to more than 50,000 volumes. The five new science laboratories are among the most modern and best-equipped in the country.

Significant in the University's program of development have been recent innovations in the general educational program. These include the Work-Study Plan; the general introductory survey courses designed to acquaint the underclass students with the three broad fields of human knowledge; the humanities the social sciences and the natural sciences; the counselling program, which aims to give each student a program of study which corresponds most closely with his capacities, aptitudes and vocational or professional needs; the granting after two years of study of titles of Associate in Arts and Sciences and Associate in Applied Arts and Sciences to those students who have met the requirements for these certificates; and President Haynes' "Plan for Individualized Life-Time Education", a program for continuous and planned adult education.

Nearly one-half of the University's faculty of 65 hold the degree of doctor of philosophy. Most other members of the faculty are engaged in graduate work toward the attainment of the doctoral degree.

PRE-VIEW DAY ACKNOWLEDGMENT

Pre-View day, to be held Monday morning, will feature two programs, one for seniors in the lecture hall directed by Dean Holt and one for underclassmen in the auditorium directed by President Haynes.

Acknowledgment for the University's recent acceptance as a member of the North Central Association of universities and colleges will be given by the president and dean.

The university gained accreditation at last, as reported in the *Gateway* extra, on March 31, 1939.

Ahuva Gershater (left) and Marjorie Disbrow rehearse "Peace" for "War and Peace Suite," the "concert of the year" in the OU auditorium in April 1940. It was choreographed by Ruth Diamond (Levinson). Pres. William Sealock, who hired Diamond in 1932 to teach physical education and dance, encouraged her to earn a master's degree at Columbia University. Gershater performed "Mocking the Dictator," in which she parodied Hitler.

Tomahawk beauty candidates in 1943 were selected by out-of-town judges "on the basis of beauty and not personality or scholastic records." Sororities, fraternities, and petitions nominated contestants. Results were announced on Ma-ie Day in the *Tomahawk*. From left to right are (first row) Bobra Suiter, Marian Ganaros, Jane Griffith, and Hazell McConnell; (second row) Nell Evans, Ruth Neef, Mary Heumann, Helen Larsen, Mary Ellen Mahoney, and Betty Lou Haas. Not pictured are Frances Olson and Marjorie Ripper.

Wartime placed increased intensity on physical education. Physical education professor Stuart Baller designed a fitness regime, including Baller's hazard course pictured here in 1942, comporting with official army- and navy-recommended calisthenic exercises. Another photograph shows students with rifles in hand going up and down the bleachers.

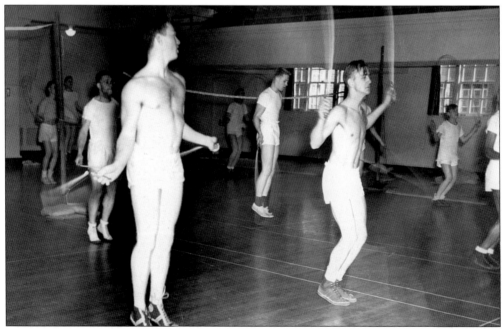

Students skip rope in the gymnasium. Coach Baller said "rope skipping is one activity which we emphasize much more than do other universities. It is a good substitute for running and is an excellent coordinator of muscles. We notice that there is a high correlation between physical fitness and ability to skip rope."

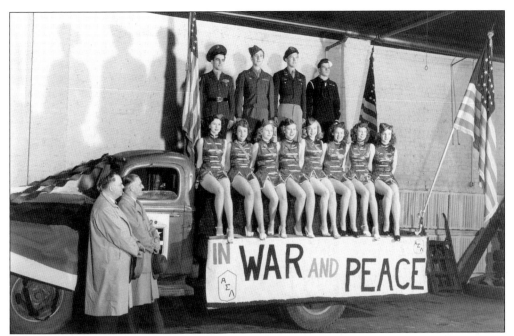

The Alpha Sigma Lambda Float, named "In War and Peace," is shown on Ma-ie Day in 1946. The judges were Omaha mayor Charles W. Leeman and OU chairman of the journalism department Robert L. Mossholder, on the left. The May 14 *Gateway* reported that the judges "tramped through a downpour" to inspect the entries.

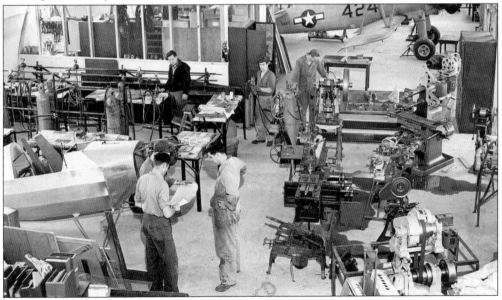

In July 1944, the university, planning for peacetime conversion, established the technical institute to train returned servicemen, displaced war industries employees, and high school graduates. The course in aircraft engine mechanics included the essentials of maintaining propeller-driven aircraft. Quonset huts were modeled on World War I British Nissen huts; ribbed corrugated curved walls initially produced during World War II in Quonset, Rhode Island, housed the engineering annex south of the administration building.

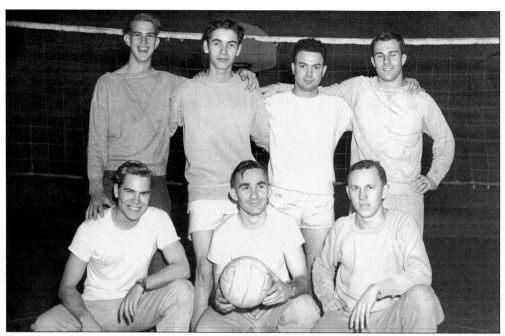

Theta Phi Delta fraternity, reactivated in 1945, won the 1946 intramural volleyball championship. From left to right are (first row) Bob Cunningham, Bob Dymacek, and Harold Hlad; (second row) Bill Rogers, Duane Finch, Bob Bloom, and Warren Gilliland. Bob Cunningham (OU, 1949), served as Interim Mayor of Omaha from November 1976 to June 1977. Bob's brother Glenn Cunningham (OU, 1935) served as Mayor of Omaha from 1948 to 1954 and in Congress from 1957 to 1971.

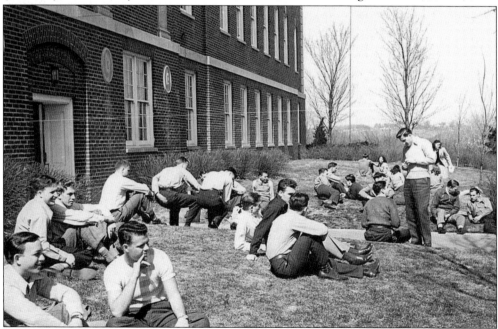

Students relax on the lawn on the east side of Arts and Sciences Hall in 1946. The haircuts and clothing are reminiscent of the television sitcoms. Compare this picture to that on page 87 depicting the same plot of land with temporary portable classrooms.

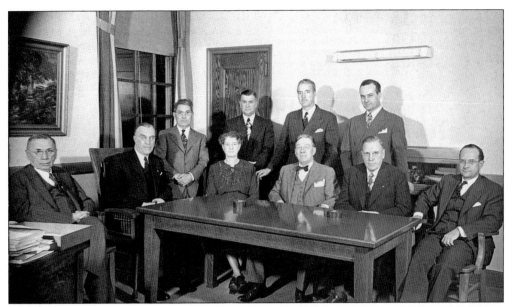

Pres. Rowland Haynes appears here with the board of regents. Sitting to the right of Haynes are Will R. Johnson (president, Northwestern Bell Telephone Company), Mary M. Bath (secretary), Farrar Newberry (vice president, W.O.W. Life Insurance Society), Herbert D. Marshall (Eaton Metal Products Corporation), and George C. Pardee (Metropolitan Utilities District). Standing are William H. Campen (Omaha Testing Laboratories), W. Dean Vogel (Livestock National Bank), V. J. Skutt (United Benefit Life Insurance Company), and Frank C. Heinisch (attorney).

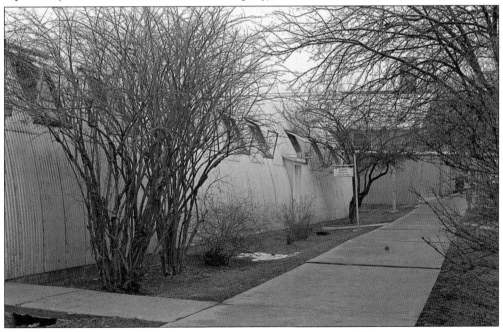

Women's physical education took place in West Quonset. In May 1946, the regents, anticipating increased postwar enrollment in September 1946, authorized the expenditure of $30,000 to purchase, erect, and equip two Quonset huts for physical education activities and storage to release space in the main building for instructional use.

Jewish fraternities and country clubs arose to avoid ostracism by predominantly Christian organizations. Pictured here in Beta Tau Kappa in 1948 are, from left to right, (first row) Milt Soskin, Hy Gendler, Jay Chasen, Marty Haykin, Mort Kaplan, Harvey Roffman, and Shelly Coren; (second row, incompletely identified) Eddie Kuklin, Willis Epstein, Marvin Kohll, Marvin Hornstein, Morrie Abrams, Marty Colton, and Harold Novak; (third row) Marvin Dienstfry, Jerry Guergil, Harold Abrahamson, Pete Knolla, Gordon Bernstein, Fred Shuerman, and Sidney Neurenberg.

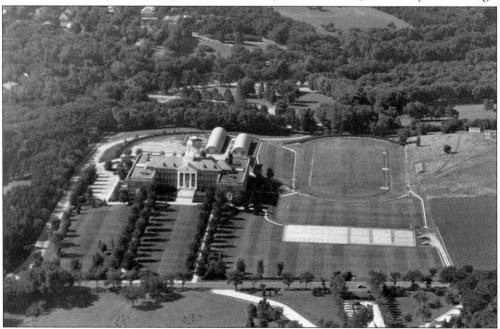

This aerial view is of the University of Omaha in 1947 before the construction of the field house. Tennis courts occupied the land that now houses the Eppley Administration Building. Two Quonset huts are on the south side of the building.

Four

THE MILO BAIL ERA
1948–1965

Universities welcomed demobilized servicemen. Enrollment boomed, and faculty were quickly hired. The GI Bill meant that many young men could go to college who hitherto would not have been able to. OU, with its proximity to Offutt Air Force Base, welcomed veterans and students still in the service. These students were known as bootstrappers. This cohort and its accomplishment is prominently featured in Bootstrapper Hall in the Thompson Alumni Center. Enrollment climbed steadily, reflecting the surge of Americans to get a higher education and the role of the university in the community.

The architectural inventory grew steadily and included the field house (1949); Eugene C. Eppley Library (1956); the student center (1958); and the Applied Arts Building (1958), subsequently renamed the Engineering Building and in late 2006 the designated home of the College of Public Affairs and Community Service; toward the end of the municipal period, plans evolved for Allwine Hall.

The era of independent municipal universities comprises an interesting if brief chapter in the history of American higher education. Sister municipal institutions in Akron, Cincinnati, Louisville, and Wichita served a vital role. They increasingly faced the competition of junior or community colleges and the growth of suburbs beyond the tax base of the urban institution. Relying on parsimonious public revenues, the mill levy, and student tuition, resulted in a financial crisis temporarily resolved by increasing student tuition. By the mid-1960s, the regents of the municipal university contemplated merging with the University of Nebraska and drawing from a statewide revenue base. Several municipal universities became state institutions between 1964 and 1970.

Philip Milo Bail, born in 1898, earned his bachelor of arts at Missouri Valley College and his doctorate from the University of Iowa in 1931. A Presbyterian, he had taught high school chemistry and physics and coached football, basketball, and track. He came to Omaha from Butler University and served as president from 1948 to 1965, during which time several buildings were erected, the AFROTC was established, and the bootstrap program started. Faculty rose from 50 in 1945 to 150 in 1964. The Eppley Foundation endowed the Milo Bail Chair of Physics in 1965. President Bail is a character in English professor Carl Jonas's novel *The Sputnik Rapist* (1973). His spouse, Josephine, died in November 1976, and Milo Bail died in January 1984 at the age of 85.

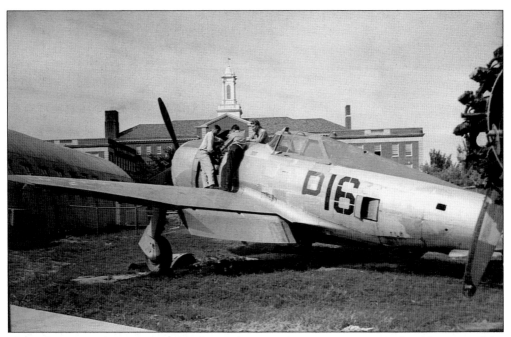

This P-47 Thunderbolt, photographed in 1949, arrived on campus in May of 1946 as part of the technical institute. The airplane flown by Dick Leed (OU, 1948) served well for instructions and awe-inspired eyes of visitors. Scheduled to be scrapped in late 1953, the *Gateway* reported that robins nested in the air duct under the fuselage.

The planting of trees and landscaping gave the grounds to the south of the university a gardenlike atmosphere, a setting for graduation on June 6, 1949. Dr. Paul F. Douglas, president of the American University in Washington, D.C., gave the commencement address "Saints Live in History." Regents V. J. Skutt of Mutual of Omaha, Robert H. Storz, and president emeritus Rowland Haynes attended the first Bail-era graduation.

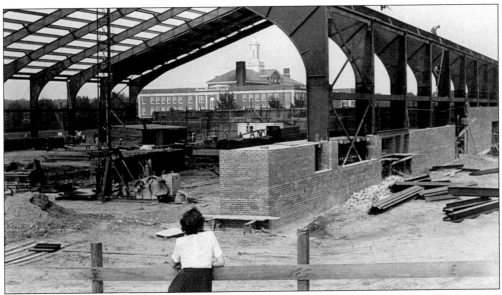

The board of regents promulgated a 10-year building plan in 1946. Groundbreaking for the second campus building, the $750,000 field house, occurred in 1948. It opened in 1949 and was dedicated in 1950. Designed by John Latenser, its rollaway bleachers seated 3,500 spectators. It had a hard dirt floor until the early 1970s. In 1998, it honored Lee and Helene Sapp. Al F. Caniglia Field on the east side honored the football coach, 1960 to 1973, who earned his bachelor's and master's degrees at OU.

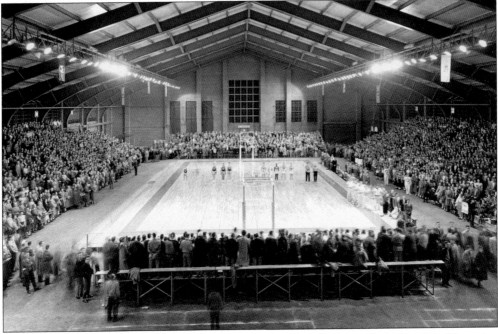

The crosstown OU versus Creighton University basketball rivalry began in 1945. OU had lost nine games in a row, coming close to winning in 1949–1950 with a 56-51 score and early in the 1953 season with a 56-54 loss. A total of 4,500 spectators saw the jinx continue at the OU field house on February 14, 1953. Creighton defeated OU 89-80 for its 10th victory.

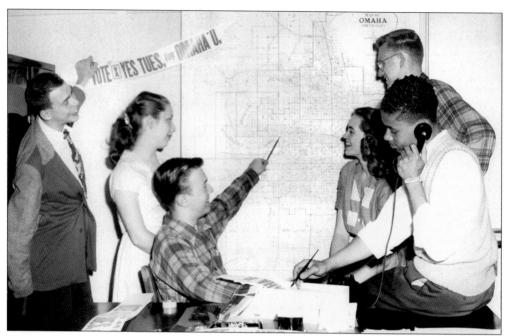

The May 15, 1951, mill levy election was vital to financing the university. Inflation outpaced local revenue sources, fulfillment of the existing OU mission, its growth plans, and the student ability to pay tuition. Faculty and students actively participated in the election, and nearly 400 students distributed campaign literature in the 204 precincts.

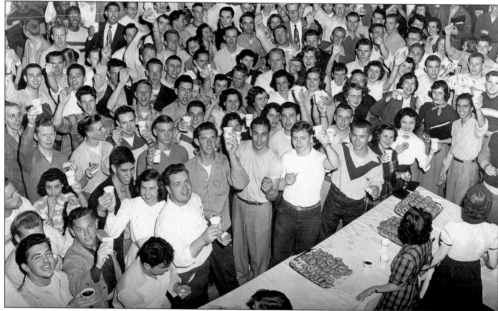

OU students celebrate the mill levy victory. A total of 26,921 voters, 51.85 percent of the electorate, approved an increase in the mill levy. Milo Bail said thank you to supporters of the mill levy by approving a skip day (canceling classes) and serving coffee and doughnuts at an all-day dance. The decline of interest in local funding during the 1960s led to the municipal university becoming a state institution.

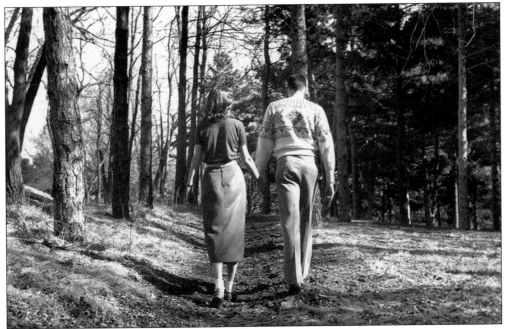

Elmwood Park, dating from about 1892, encompasses 216.4 acres and contains an 18-hole public golf course. It has seen countless picnics, barbecues, softball and volleyball games, cross-country skiers, and citizens walking their dogs. This 1952 photograph reveals its romantic side, hand-in-hand walks.

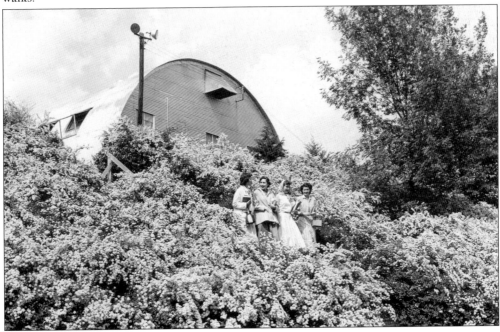

The blooming spirea along stairs south of Quonsets reveals the parklike atmosphere adjacent to the campus. The expansion of enrollment outpaced the construction of brick-and-mortar buildings. Temporary metal Quonset hut classrooms became an almost permanent fixture after World War II and into the 1970s.

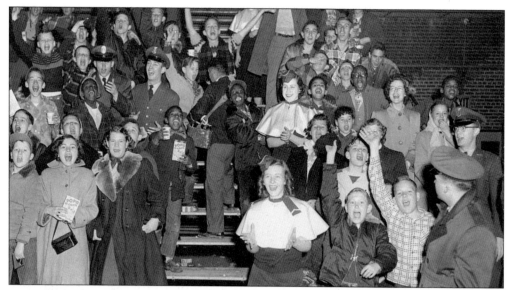

The OU Arnold Air Society (ROTC) sponsored the Junior Jets, chosen from area schoolchildren interested in aviation and football. They shouted out their yell, "Shoot 'em down in flame. We'll take the blame. Zoom, Omaha, Zoom," from their special section at OU football games. This picture is from the OU versus South Dakota Wesleyan game played on February 7, 1953. Members received Junior Jets wings. The young women in white capes belonged to Angels' Flight, a group associated with the Arnold Air Society, chosen for their interest in aviation and their "personal charm."

Guests at the April 24, 1953, second annual AFROTC Military Ball at Peony Park include (from top left, clockwise) Nebraska governor Robert Crosby; Gen. Curtis LeMay; Elizabeth Crosby; Maj. Gen. Earl S. Hoag; OU president Milo Bail; Arlene Davis, a leading aviator; and Josephine Bail. OU's Arnold Air Society chapter, the Earl S. Hoag Squadron, honored Iowa-born Hoag, a Signal Corps sergeant in 1917, who served in the Africa–Middle East, India-China, and Europe wings before retiring after 36 years of service.

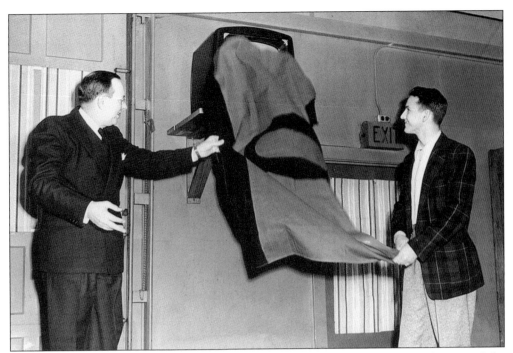

Television comes to campus. Pres. Milo Bail and student council president Ben Tobias unveil the new Philco 17-inch television in the student center in February 1952. KMTV and George Roth's Paramount Radio Shop donated the television.

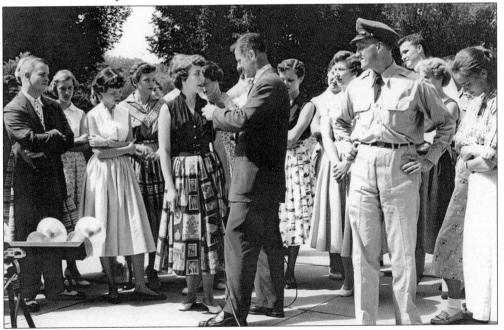

Journalism major Betty Ellsworth (Davis) (OU, 1956) is interviewed by prominent news personality Clete Roberts for *Street Corner USA* about Midwest isolationism. The program aired nationally on October 10, 1954. Ellsworth became executive director of the Douglas County Historical Society in 1997.

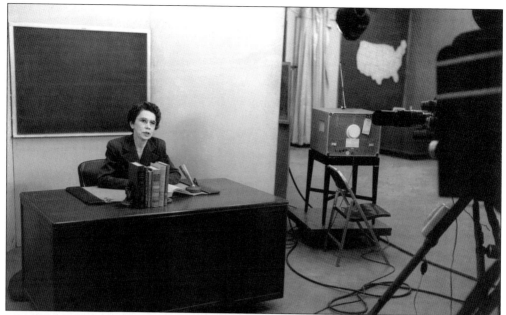

Ellen Lord, head librarian from 1938 to 1969, quickly capitalized on television and the possibilities of distance learning. Lord, an instructor in the College of Education, offered *A Survey of Contemporary Books* in the fall of 1953, on Friday morning, 10:45 to 11:00 a.m. Among the readings were Willa Cather, Theodore Dreiser, Rachel Carson, and Herman Wouk. Other programs included *American Political Parties*, *Human Growth and Development*, and *Family Financial Management*.

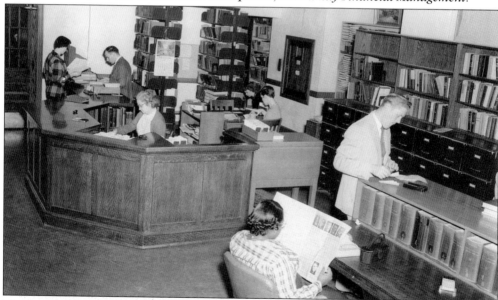

The circulation desk in the library in Arts and Sciences Hall room 220 is seen in 1955. A well-worn *Readers Guide to Periodical Literature* is in the lower right. Researchers relied on interlibrary loans to support their scholarship. The *National Union Catalog* and later Worldcat identified the location of books, pamphlets, or journals. Requests went out by mail, then by teleprinter, and now by e-mail. This section of Arts and Sciences Hall today houses the philosophy department, honors program, and faculty senate.

Stanton W. Salisbury (1913), born in Decatur, Nebraska, in 1898, became a Presbyterian minister. He joined the navy in 1921, served on six ships, including the USS *Omaha* and battleship USS *Pennsylvania*, and was at Pearl Harbor on December 7, 1941. He received the first citation for alumnus achievement. At the OU homecoming game with Northern Illinois on October 31, 1953, are (from left to right) Paul Selby (OU, 1915), captain of the 1914 football team; Don Maseman, captain of the 1953 football team; Rear Adm. Stanton Salisbury; and Jerry Ziehe. Salisbury retired from the navy as a rear admiral in 1953 and died in 1966.

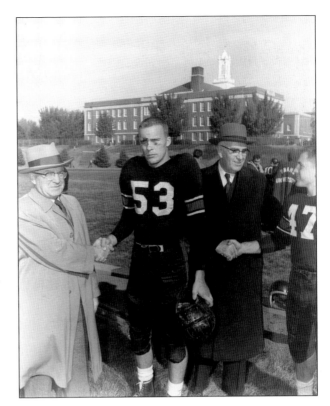

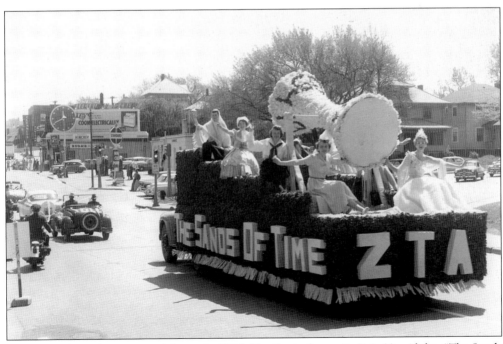

Omaha celebrated its centennial year in 1954. The float of sorority Zeta Tau Alpha, "The Sands of Time," won third place. The Zetas skit "The Masterpiece" won first place.

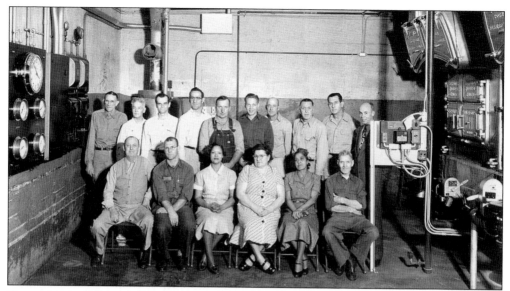

The support staff are vital to the university learning environment. The mail room, telephone switchboard, cleaning crew, campus security, and cafeteria workers make the life of students, faculty, and administrators easier. Buildings and grounds staff in 1954 pose in the basement of the administration building. Incompletely identified only by last name in the *Tomahawk*, pictured here are, from left to right, (first row) McQuin, Krenzer, McKinley, McNabb, Mitchell, and Hanna; (second row) Wood, Livingston, Little, Cook, Harder, Johnson, Spangler, Urban, Hiatt, and Adwers.

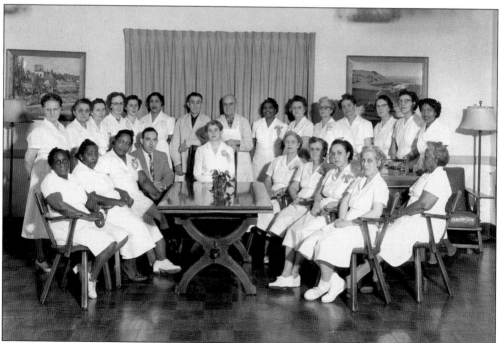

Cafeteria workers are shown in 1954. These cafeteria and student center workers, 22 women all in white uniforms and 3 men, are nonunionized workers. In March 1973, the university introduced the employee of the month program to enhance productivity and morale.

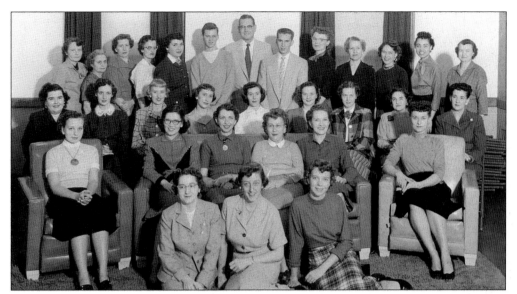

A total of 30 women and three men staffed the business and registrar office. Incompletely identified only by last name, pictured in the 1954 *Tomahawk* are, from left to right, (first row) Harsh, Baker, and Paul; (second row) Nelson, Lawrence, Judy, Benson, and Baumfalk; (third row) Croft, Ashmore, Bevelheimer, Mahoney, Watson, Forinash, Swanson, Huntington, and Sigler; (fourth row) Alexander, Markey, Robers, Bahensky, Decker, Hamlin, Gerbracht, Keil, Pavles, Sinett, White, Bryant, and Engle. William Gerbracht, the tall man in the back center, served in many personnel positions from the 1950s, including registrar from 1977 to 1989.

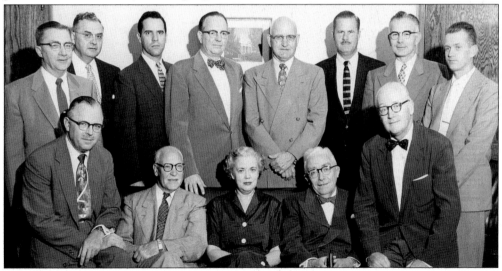

Pictured is the University of Omaha Administrative Council, 1955–1956. Pictured are, from left to right, (first row) Roy Robbins, director of the graduate division; Carl Helmstadter, dean of applied arts and science; Alice Smith, registrar; W. H. Thompson, dean of arts and sciences; and Jay B. McGregor, dean of student personnel; (second row) Charles Hoff, vice president of business management/finance secretary; Frank Gorman, dean of the College of Education; Donald Emory, dean of the College of Adult Education; Pres. Milo Bail; John E. Woods, director of placement and AFROTC liaison; Roderic Crane, assistant to the president; John Lucas, dean of business administration; and Robert McGranahan, director of information.

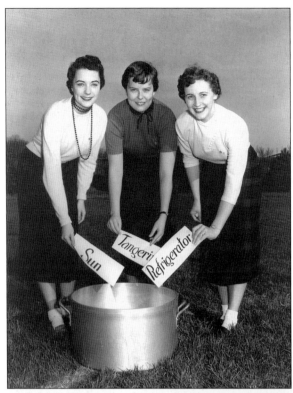

Where will the OU football team go bowling? From left to right, Corinne Houser, Beverly Thoma, and Shirley Decker hold prospective bids. The 1954 OU Indians, with their first undefeated and untied season in the history of the school, received feelers from the Mineral Bowling Excelsior Springs, Missouri; Sun Bowl in El Paso, Texas; Refrigerator Bowl in Fort Wayne, Indiana; and Cigar Bowl in Tampa, Florida. They opted to play in the Tangerine Bowl in Orlando, Florida, on New Year's Day, 1955.

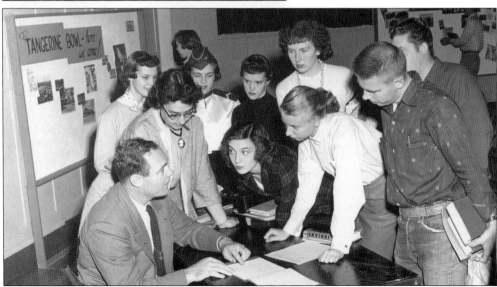

Assistant dean of student personnel Don Pflasterer signs up students for a trip to the Tangerine Bowl Trio in Orlando, Florida. Orlando offered 100 students room and board in a private home, in return for the friendliness Omaha had shown when hosting the Rollins College (Winter Park, Florida) baseball team during the NCAA meet in Omaha. Bowl tickets were $1.50 to $4.75. The 38-hour Greyhound bus trip cost $43.41. Round-trip fare by train was $77.17 to $128 for a Pullman. The *Gateway* sponsored a Tangerine Queen contest based on "figure, beauty, poise and charm." The winner, Jackie Pedersen (OU, 1955), received a free trip to Orlando.

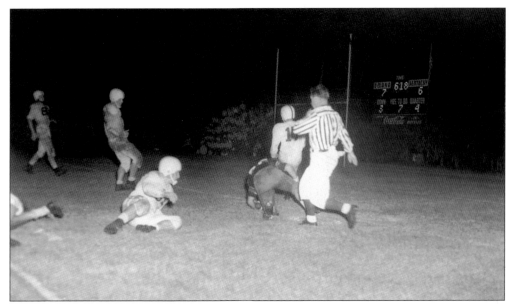

Kentucky defense (white) surrounds a tackled OU ball carrier. The scoreboard with 6:18 left in the game shows the final score: Omaha 7–Eastern Kentucky State 6. The Indians finished the 1954 campaign with a perfect 10-0 record and a 14 game winning streak. OU head Coach Lloyd Cardwell play for the Detroit Lions in the late 1930s, line Coach Tom Brock had been the starting center at Notre Dame for three years.

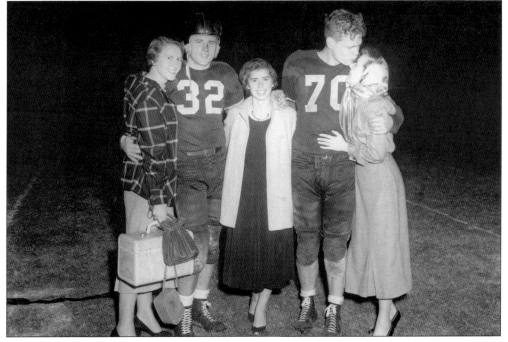

Students were all smiles following OU's 7-6 victory. Pictured are, from left to right, Bonnie Radik, Emil Radik, Joyce Tannahill, Harry Johnson, and Gloria Johnson. Radik, the second-highest rusher, scored eight touchdowns during the 1954 season. Bill Engelhardt, not pictured, ranked first in both categories.

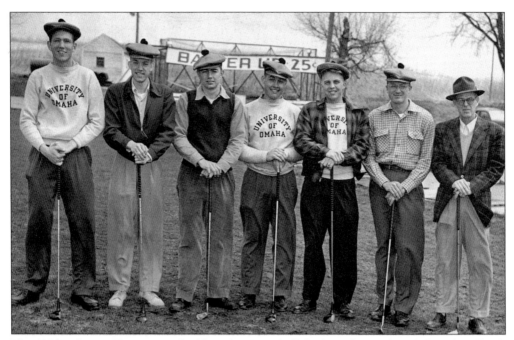

The 1954 Indian golf team, coached by John Campbell, had a 9-4 record. It defeated Midland, Washburn, Drake, Doane, Creighton, Nebraska Wesleyan, and Morningside and lost to the Big Seven schools, Nebraska, Iowa State, and Colorado. From left to right are Fred Shimrock, Don Fitch, Dean Wilson, Bill Campbell, Jerry Norene, Arch Templeton, and John Campbell.

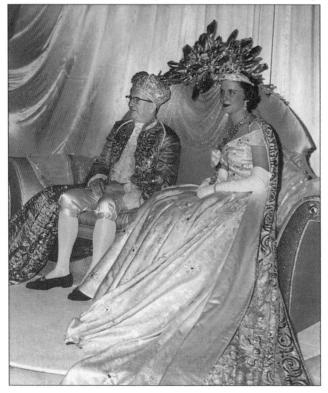

Pres. Milo Bail, the 61st Ak-Sar-Ben King of Quivera in 1955, is accompanied by queen Ann Pettis, a 1953 Wellesley College graduate. Bail credited receiving this honor after seven years in Omaha to the faculty, staff, and students who brought distinction to the university. Chancellors Ronald Roskens and Del D. Weber served as kings in 1980 and 1990, respectively. The Milo Bail Student Center contains an Ak-Sar-Ben room. Another index of the university community involvement is the chancellor's leadership in the United Way of the Midlands campaigns.

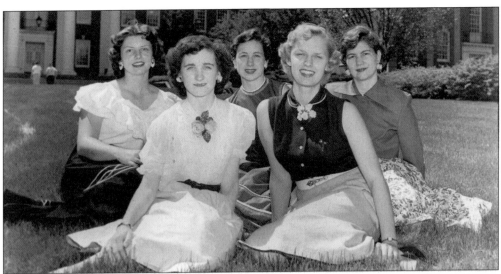

Ma-ie Day Princess Attira XXI is shown in 1955. Pictured are, from left to right, (first row) Faith Stitt and Jane Andersen; (second row) Virginia Cline, Donna Reynolds, and Joanne Rentschler. The winner, 21-year-old senior Reynolds, a College of Business Administration retailing major, received a World-Herald Scholarship. She was treasurer of Chi Omega, flight leader of Angels' Flight, secretary of the Retailing Club, chair of the Library Cornerstone Committee, a student council member for two years, and queen of the 1954 junior prom. Ma-ie Day activities included an annual parade through downtown Omaha, a dance at Peony Park, and a newly initiated athletic contest.

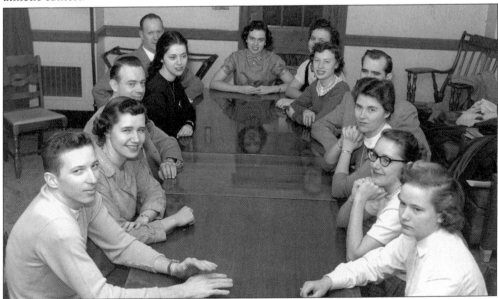

A few days after taking this photograph of the Westminster Fellowship Group, 20-year-old Carolyn Nevins (second from left), an excellent student, history department tutor, part-time library worker, and a member of several campus organizations, was murdered. An unknown assailant shot her four times while she waited for a bus to take her home from campus. Despite a thorough police investigation, including 92 people taking lie detector tests, the December 9, 1955, murder remains unsolved.

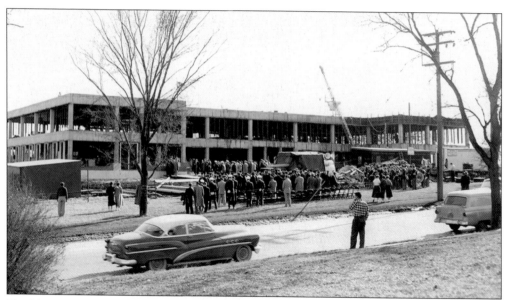

The library cornerstone-laying ceremony was held on March 29, 1955. Dodge Street is in the foreground. The cornerstone box contained 1955 mementos. John Latenser and Sons designed the building. The April 1, 1955, *Gateway* also noted that the regents tabled plans for a proposed three-level parking garage to be carved from the hill south of the administration building. This $750,000 investment would have improved the parking, then limited to 764 student, 136 faculty and staff, and 10 visitor spaces.

The Eugene C. Eppley Library dedication was held on February 5, 1956. Eppley, who came to Omaha in 1921 to operate the Fontenelle Hotel, ran 22 hotels throughout the country. His generosity to OU started in 1949 with $7,500 to outfit the marching band and to prepare architectural drawings for a new library. In 1955, he donated $850,000, the largest sum given the university to that time, to build a library. The Eppley Library subsequently became the Eppley Administration Building. Eppley sat on the board of Braniff International Airlines and died in 1959. His portrait hangs in the building named in his honor.

The Eppley Library study hall is pictured here. Apart from holding books, libraries provide quiet space for students to study. This picture depicts the standard-issue blond wood sturdy library tables and chairs, and the predominance of male students.

Registration was held in the field house in the fall of 1955. During the mid-20th century, registration invariably took place in the gymnasium. Paul C. Kennedy, on the right, born and educated in Kansas, came to OU in 1955 to head the Department of Secondary Education. Kennedy served as dean of the Education College from 1967 to 1974. His cowboy hat made him clearly visible on campus. This particular registration set a record of 2,125 registrants, including 800 freshmen.

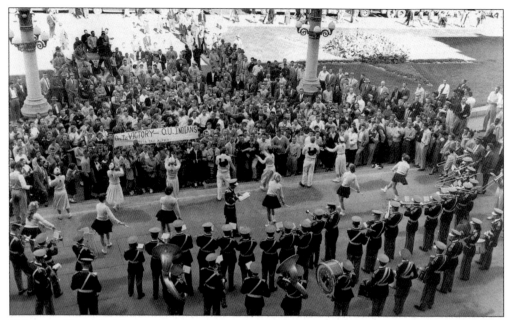

This pep rally was held on the Douglas County Courthouse steps (facing current Woodman Tower) on Friday, October 14, 1953 prior to a rematch with Eastern Kentucky State University. The band paraded through the school halls and rode downtown for a rally. Classes at 11:00 a.m. and noon were cancelled. Gov. Victor Anderson; Mayor John Rosenblatt; and Sandy Speicher, Miss Nebraska of 1955, were introduced at halftime. OU won the rematch 20-13 in Omaha Municipal Stadium.

The OU choir rehearses in preparation for performance of "The Seven Last Words of Christ on the Cross" by Heinrich Schutz (1585–1672) for the Easter 1956 convocation in the auditorium. The 10:00 a.m. classes were dismissed to permit attendance. John D. Miller led the choir, and bandleader Arthur Custer coordinated the production.

This is the College of Adult Education registration line in the fall of 1956. In 1952, the regents created the College of Business Administration and the College of Adult Education to attract adults returning to school. Omaha had no junior or community colleges until the early 1970s. Classes ran continuously from 7:00 a.m. to 10:00 p.m. In 1956, OU had 2,300 day students and 2,500 night students. Adult education dean Donald G. Emery stated the "program of adult education includes almost every phase of intellectual development, vocational training, and cultural enjoyment."

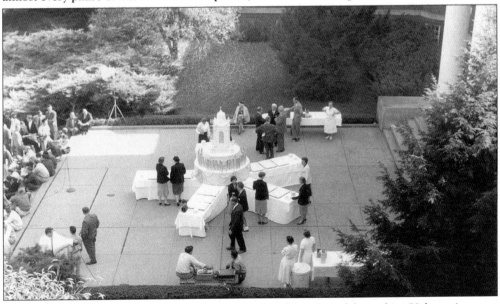

On Founders' Day, October 8, 1958, the University of Omaha celebrated its 50th anniversary. During the gala reception, 300 guests, alumni, and regents feasted on ambrosia, roast suckling pig, pearl onions, and lots of coffee. The students ate cake. Rear Adm. Stanton Salisbury spoke about "Yesteryear, 1908–1931," regent Farrar Newberry, past president of the Woodmen of the World Life Insurance Company, spoke on "Changing Times, 1932–1948," and Dr. Milo Bail addressed "Up to Now and a Look Ahead, 1949–."

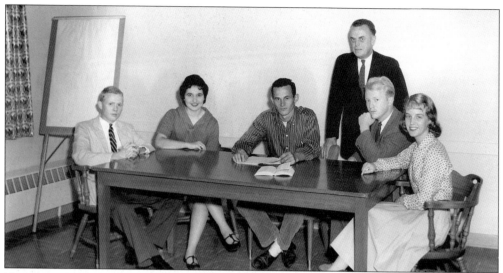

The *Grain of Sand*, a student publication, took its name from "Auguries of Innocence" by 19th-century English poet William Blake. Pictured here are, from left to right, Tom Morrow, Rosalie Cohen, Carl Sherman (editor), Dr. Ralph M. Wardle (sponsor), Warren T. Francke, and Barbara Blake. Wardle taught from 1938 until his forced retirement in 1976. He stated, "Really, I'm just a teaching fool. There are just two things in the world I always want to do . . . to teach and to write." He wrote several books, including *Mary Wollstonecraft, A Critical Biography* (1951). He taught at Creighton University, which had no mandatory retirement. He died in 1988 at the age of 79 and is remembered by the English department's Ralph Wardle Chair.

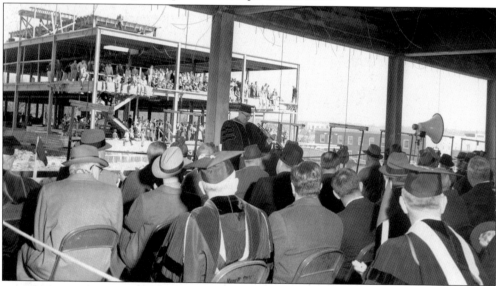

Pictured here is the Applied Arts and Student Activities Buildings cornerstone-laying ceremonies. Milo Bail is at the podium in the Applied Arts Building, which is under construction. Students watch the activities from the Student Activities Building, also under construction. The cornerstones were to have been set on December 5, 1958, but the cold weather lead to an "indefinite postponement." Two 500-pound cornerstones set on March 13, 1959, held a copper box containing a Bible, faculty autographs, a 1958 commencement program, and copies of the *Gateway,* the *Grain of Sand,* the *Tomahawk,* and the *Omaha World-Herald.*

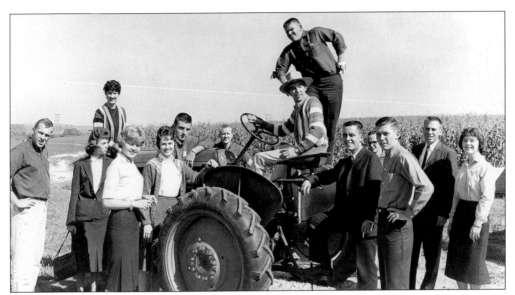

The urban campus is on the edge of a prairie. Arthur A. and Antoinette K. Allwine donated their 160-acre Glen Haven Farm near Bennington to the university in 1959. They brought back deer, rabbits, birds, and fish by planting appropriate flora and creating lakes with dams. In 2006, T. L. Davis donated a 22-acre wooded parcel, along the bluffs of the Elkhorn River near 245th and Q Streets, to UNO in honor of his father, Thomas L. Davis. The oak forests and savannas, sandstone cliffs, and streamside habitats facilitate teaching botany, biology, environmental studies, research, and outreach activities.

This OU theater presentation in February 1960 of *The Happiest Millionaire* by Kyle Crichton starred Peter Fonda (right), son of Henry Fonda. Three performances were given of this two-act comedy. The *Omaha World-Herald* reported that "the play oozes amusing characters." Peter played a "poker-faced butler." Peter, born in 1940, went on to perform in over 80 films, including *Easy Rider* (1969).

During the height of McCarthyism, Milo Bail rejected funds to pay for lectures promoting right-wing politics. He wanted to keep politics at a distance from campus. OU's Young Democrats invited Robert F. Kennedy, campaign manager for his brother John F. Kennedy, to speak on campus on September 23, 1960. Robert addressed farm issues, raising the minimum wage to $1.25, and medical aid for the elderly. Robert, formerly legal counsel for the Senate Rackets Committee, sidestepped questions on whether he would receive an appointment if his brother won the election. He became attorney general. The "White House," once the student snack shack, in 1960 was a physical education classroom.

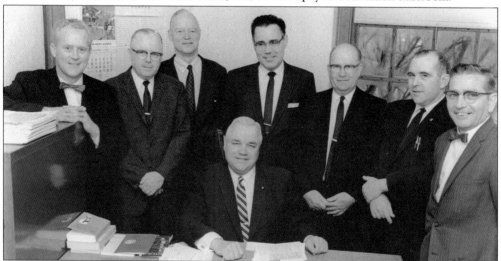

The history faculty in 1962 includes chairperson A. Stanley Trickett (seated) and, from left to right, Paul Beck, Roy Robbins, Casper Offutt, Thomas Neville Bonner, Fred Adrian, Ray Miller, and Ert Gum. The Omicron chapter of Phi Alpha Theta, the national history honorary society founded in 1921, started at OU in 1934. During the past 50 years, the department awarded over 250 master's degrees, and at least 60 students went on to earn doctorates. Bonner, unsuccessful for Congress against Glenn Cunningham, wrote several books on medical history and became president of Union College in New Hampshire and Wayne State University in Detroit.

The AFROTC Detachment 470 Rifle Team, 1959–1960, is shown. ROTC arrived at OU in 1951. A university degree could lead to an officer's commission. The rifle team and the drill team, known as the Sabres, sporting new uniforms, competed in invitational drill meets. The Sabres came in sixth out of 23 teams competing at the Illinois Invitational Drill Meet in Champaign, Illinois, in April 1960. The popularity of the rifle team in 1960 caused coach S.Sgt. Darrell Goodwyn to form two teams. ROTC on campus became a heated topic across the nation in the late 1960s.

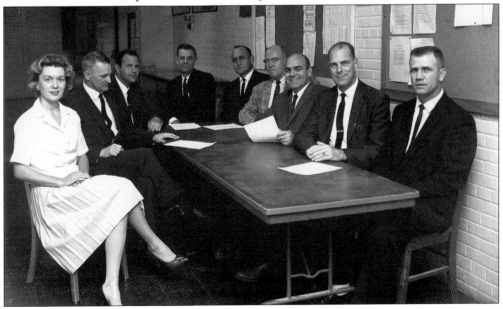

Members of the OU athletic department, Marilyn Hamilton, James Borsheim, Russell Gorman, Virgil Yelkin (athletic director), Don Watchorn, Ernie Gorr, Al F. Caniglia, Lloyd Cardwell, and J. Kenneth Fischer, from left to right, are in the field house basement in 1962.

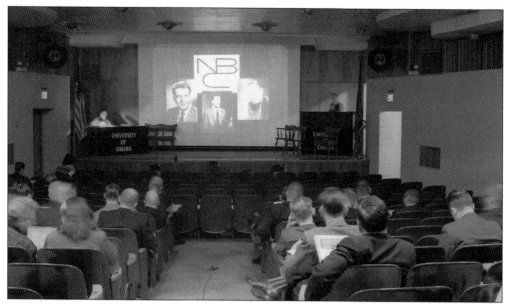

The University of Omaha participated in the first national Tele-Lecture Conference in Eppley Auditorium, December 3–5, 1962. Nationwide there were 2,500 viewers. Some 250 university presidents were on television and on the telephone, including Sargent Shriver, director of the U.S. Peace Corps, and Dr. Harry Scherman, chairman of the board of the Book of the Month Club, among others. On Friday nights during the 1970s, the auditorium featured foreign and independent films that did not normally appear in Omaha's commercial theaters.

Don Benning attended OU during the 1950s and was on the wrestling team. When hired in 1963 as wrestling coach, he was one of the few African Americans to serve in this capacity at a predominantly white university. The 1964 *Tomahawk* stated, "The Indian wrestling squad sported a 5-6 record. The inexperienced team, coached by Don Benning, shows promise for the future." UNO won the NAIA championship in 1970.

The fifth annual Theta Chi Olympics took place at the OU field house on February 16, 1963. Members of the Theta Chi fraternity chose their Helen of Troy from among Susan Rester, Zeta Tau Alpha; Susan Krogh, Chi Omega; Darlene Utterback, Sigma Kappa; and Gail Enquist, Alpha Xi Delta. Helen was "chosen on the basis of the originality of her costume, poise and beauty." Activities included chariot racing, pyramid building, a tricycle race, and a tug of war. New contests were egg throwing and bed piling, the greatest number of persons on a mattress without touching the ground.

Members of the Independent Student Association were up at 5:00 a.m. in the snow putting Santa hoods on 956 parking meters, their Christmas gift to students. They adjourned to the Town House at Seventy-first and Dodge Streets for breakfast.

Women's physical education class took place in Quonset huts. The Quonset huts purchased in 1946 were still in use in 1963.

Shown is the Glenn L. Martin Shop in the Applied Arts Building in 1964. Glenn Martin, president of Glenn L. Martin Company of Baltimore and chairman of the board of the Martin-Nebraska Company, whose Martin Bomber Plant produced the B-26 Marauder and the B-29 Superfortress, received an honorary degree in 1945. The commencement speaker, Wayne W. Parrish, editor and publisher of American Aviation Publications, gave an address titled "Education for the Air Age." Martin died in 1955, bequeathing OU $100,000.

Students load a truck for Greek Help Week in March 1964. Greeks painted the Lutheran Old Peoples' Home at 520 South Twenty-sixth Street as their good deed for 1964. A banquet and the Sig Ep Sing closed a week of painting. Alpha Xi Delta, Lambda Chi Alpha, Chi Omega, Tau Kappa Epsilon, Sigma Kappa, and Theta Chi participated in a song competition.

On Ma-ie Day, May 8, 1964, wheelbarrow races were held south of Eppley Library.

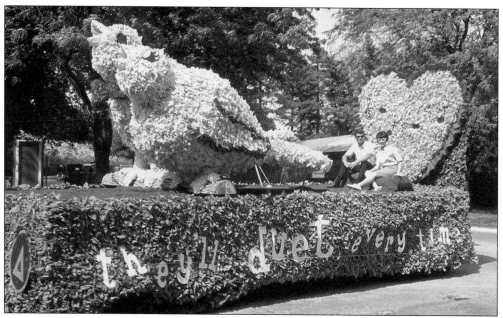

During Ma-ie Day in 1965, the Alpha Xi Delta float "they'll duet every time" won the award for best use of materials. A total of 13 floats and 130 gaily decorated cars paraded from campus to downtown, past Creighton University, and returned to campus. Festivities included a TGIMD (Thank Goodness It's Ma-ie Day) dance in front of the administration building and a dance at Peony Park.

Lt. Col. Emilio P. Ratti, professor of aerospace studies, commissions Herbert C. Rhodes, the Distinguished OU AFROTC Graduate, among the seven graduates at the AFROTC commissioning ceremony on June 7, 1965. Rhodes received the Pen and Sword Trophy for outstanding achievement. Gen. Albert C. Wedemeyer, a 1919 West Point graduate who retired in 1957 and served in China and the Philippines, gave the commencement address.

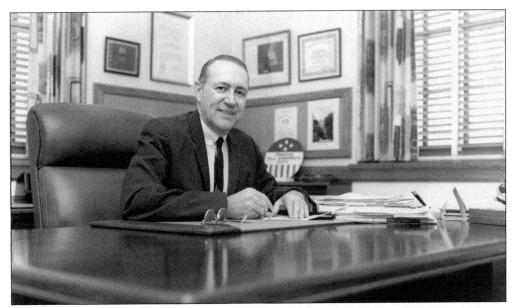

Leland E. Traywick, OU's eighth president (1965–1967) had been president of Southwest Missouri State College since 1960. The Vietnam War, rising higher education costs, and Omahans rejecting mill levy hikes moved the regents to contemplate merging with the University of Nebraska, the latter opposed by Traywick. Emeritus president Milo Bail supported a "Greater University of Nebraska." The regents and Traywick came to an impasse. Traywick submitted his resignation in December 1966. Kirk E. Naylor became acting president.

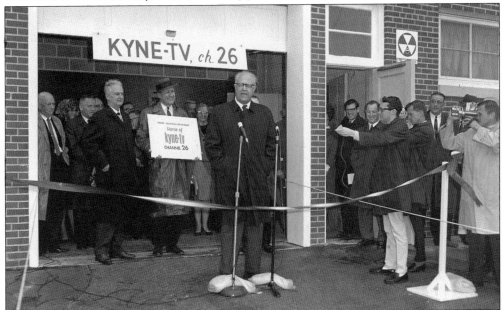

The 407-foot KYNE-TV tower served the University of Omaha through the Metropolitan Omaha Educational Broadcasting Association. Nebraska governor Frank Morrison, superintendent of Omaha public schools Paul A. Miller, and OU president Leland E. Traywick presided over the dedication and ribbon cutting of the KYNE-TV tower on March 22, 1966. A light rain and brisk wind attended the quickly held ceremony.

Angels' Flight sponsored the December 1966 Toys for Tots campaign. From left to right are Lois Prazan, Sue Bowen, Toni Matson Westphalon, and Paula Magzamin. A new toy provided admission to the Angels' Flight dance. Toys for Tots started as a national Marine Corps program in 1947. They collected and distributed the toys to underprivileged children.

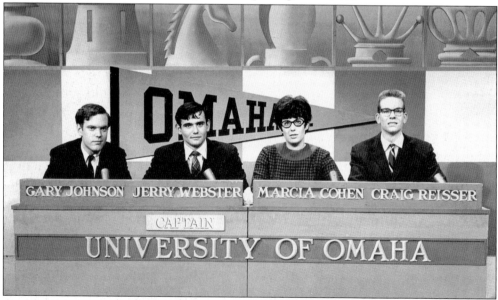

OU students went to the GE College Bowl in New York City on February 19, 1967. The bowl started on radio in the early 1950s. Three seniors and a sophomore were coached by Dr. Victor Blackwell (art), Cliff Anderberg (philosophy), Arts and Sciences dean Robert Harper, Richard Lane (English), Jack Hill (business), Paul Beck, Ert Gum, and Harl Dalstrom (history). They lost to Texas University and went home with a consolation prize of $500. The program attracted eight million viewers. They saw *Man of La Mancha* while in New York.

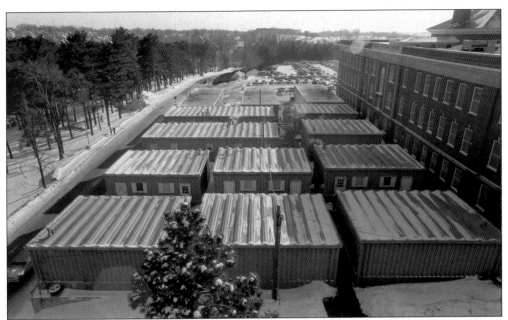

The temporary annexes purchased in 1968 were placed on the east side of Arts and Sciences Hall. These temporary buildings, necessitated by rising enrollment, cost $119,988.40, plus utility lines and sidewalks. They were uncomfortable, poorly air-conditioned, and felt clammy. The Quonsets and the portables ranked with limited parking as the least-pleasant campus features. The temporary annexes were removed in 1987, and the site is now a parking lot.

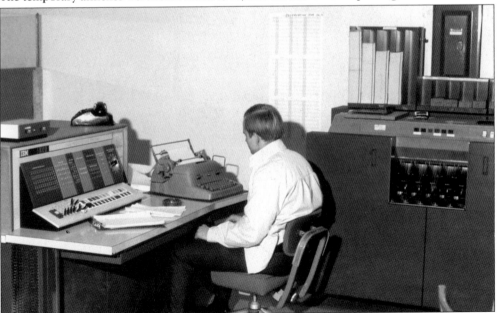

The computer center, located in the Engineering Building, room 186, in 1968, housed the IBM data processing system. Computer science appeared in the mathematics curriculum in 1960. The 1967–1968 catalog states, "As modern computational techniques become an integral part of many fields of study, the Center is used to introduce the student to these techniques. Faculty members and graduate students use computers as a research tool."

Acting University of Omaha president Kirk E. Naylor and the final University of Omaha regents are at the commencement on June 5, 1967. From left to right are Herbert H. Davis; Clarence F. Moulton; Margaret R. Fischer, B.A., LL.B. (both 1929); Drexel J. Sibbernsen, B.A. (1948), President Naylor, Robert R. Fraser, Robert M. Spire (a prominent, public service–oriented Harvard Law graduate and talented pianist, and Nebraska attorney general in the wake of the Paul Douglas Commonwealth Savings scandal), Richard W. Nisley, Arthur B. Pittman (veterinarian), and Samuel M. Greenberg ("Mr. South Omaha" businessman). Omaha voters defeated mill levy increases in 1963 and 1966. The regents favored merger with the University of Nebraska. On December 12, 1967, voters overwhelmingly favored merger, 40,035 to 10,753.

Pres. Kirk E. Naylor; Elton S. Carter, graduate college dean; and W. H. Thompson, professor emeritus, preside at OU's final commencement on June 1, 1968. Addresses were given by Oldham Paisley (OU, 1916), "The Early Years: 1908–1931—The University of Omaha"; Randall W. Owens (OU, 1969), "The Growing Years: 1931–1968—The Municipal University of Omaha"; and President Naylor, "The Future Years: The University of Nebraska at Omaha."

Five

LEARNING TO LIVE IN A
STATE INSTITUTION
1965–1997

The *Gateway* reported that "The last independent municipal university in the United States expired . . . with the approval of the OU – NU merger." The merger created expectations. The merger reduced property taxes and student tuition. The *Gateway* rejoiced at the prospect of graduate courses and doctorate programs. UNO grew by every yardstick—enrollment, budgets, square feet of educational facilities, and the role of the campus in society.

The civil rights movement increased awareness of ethnic diversity, multiculturalism, and gender. UNO established the Black Studies program in 1971, Women's Studies in 1988, Native American Studies (NAMS) in 1992, Chicano/Latino Studies in 1995, and the Office of Latino/Latin American Studies of the Great Plains (OLLAS) in 2003. Starting in the 1970s, affirmative action and equal opportunity became national concerns. Hubert G. Locke, the first permanent dean of the College of Public Affairs and Community Service, 1972–1976, was also UNO's first African American dean. The status of women as students, faculty, and administrators changed dramatically during this period. In 1979, the enrollment of women outnumbered men, and in 1980, more women graduated than men. Federal law required the upgrading of athletic facilities for women. Karen White, who led the College of Fine Arts in 1993, was the first female college dean.

Pres. Kirk E. Naylor in 1967 guided the poorly funded municipal institution to hopefully greater state support. John Victor Blackwell succeeded Naylor as interim chancellor in 1971. Ronald Roskens came from Kent State University to UNO in 1972 as chancellor. In 1977, the regents appointed him president of the entire University of Nebraska system, a position he filled until 1990. He directed the United States Agency for International Development (USAID) during the George H. W. Bush presidency. Del D. Weber, a Columbus, Nebraska, native, graduated from the University of Nebraska and progressed as an administrator at Cleveland State University and Arizona State University. He served as chancellor at UNO from 1977 to 1997. Upon retirement, he won a seat on the Omaha Public Power District board and was active in the Douglas County Historical Society.

Robert M. Spire, the last chair of the OU regents, speaks at the merger ceremony on July 1, 1968. Seated in the front row are Pres. Kirk E. Naylor, Gov. Norbert T. Tiemann, University of Nebraska president Clifford M. Harding, Herbert Davis, and John Victor Blackwell.

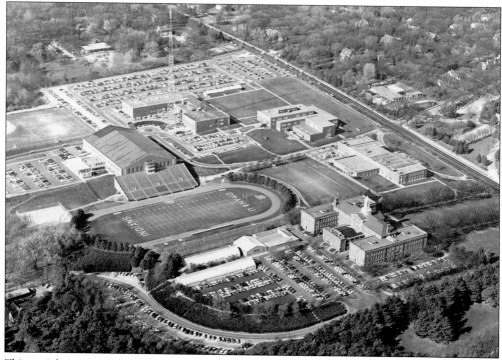

This aerial view is at the end of the municipal era. This picture should be compared to the last picture in the book on page 125.

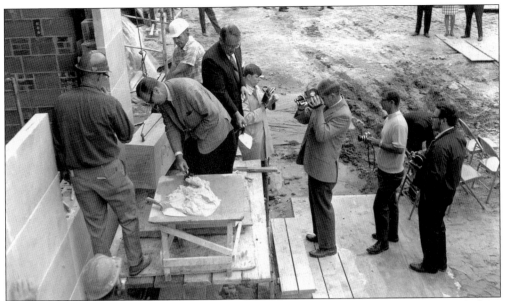

Allwine Hall, designed by John Latenser with A. Borchman Sons as general contractors, has been described as a "nondescript, four-story brick building plopped down in the middle of the UNO campus." In the late 1960s, a two-story, $1.3 million municipal proposal gave way to a $3.5 million five-floor UNO structure, as funding shifted from federal to state resources. UNO chancellor Kirk E. Naylor sets the cornerstone on June 23, 1969. The building, dedicated in 1970, housing biology and chemistry, was named for Arthur A. Allwine.

The merger boosted university enrollment and expectations. The campus was crowded on the first day of classes in September 1969, as this photograph inside the Milo Bail Student Center suggests. Campus expansion relied on planning, design, priorities, and funding. Three architectural students, employed by the City Planning Department, proposed three parking garages, with 6,000 stalls and costing over $9 million. The focus on Elmwood Park and private residences spurred the Friends of the Park Committee to take defensive action. The first parking structure emerged in 1984.

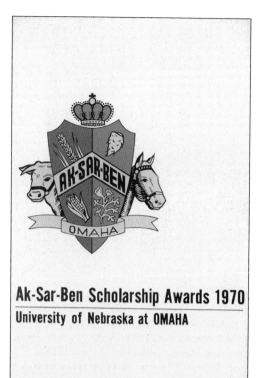

Ak-Sar-Ben Scholarship Awards 1970
University of Nebraska at OMAHA

The Ak-Sar-Ben Scholarship program, started in 1960, provided aid for scholastically worthy and financially needy students. This pamphlet contains the photographs of the Ak-Sar-Ben governors and councilors and the 64 recipients of scholarships totaling $12,500. Ak-Sar-Ben provided financial assistance to policemen enrolled in law enforcement and corrections programs at UNO and teachers wishing to attend graduate school.

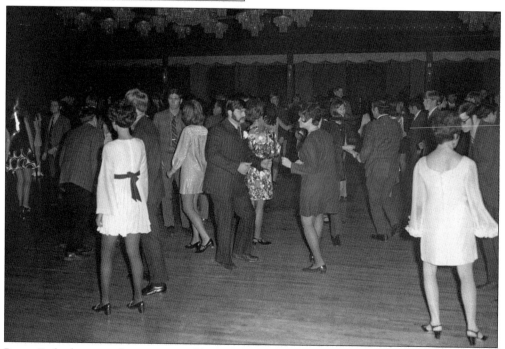

Peony Park, the venue for proms, weddings, banquets, and other celebrations for three-quarters of a century, closed in 1994. The land was reutilized for a supermarket and parking lot. At the spring 1970 prom, students danced to the music of Red Dogs from Lawrence, Kansas.

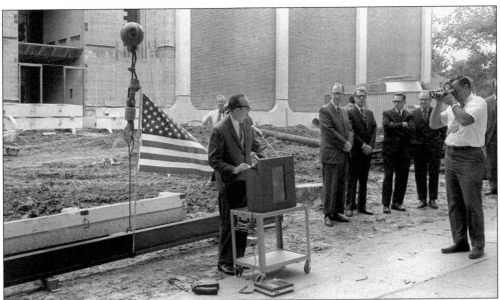

The topping ceremony installed the last beam in the structure at Kayser Hall on September 21, 1970. Pres. Kirk E. Naylor is at the podium; Kirkham Michael and Associates designed the building. Kayser Hall, completed in 1971, was the first campus building erected with state funds. The four-story building is named after Frederick W. Kayser (1874–1955), who had been president and treasurer of the Thomas Kilpatrick and Company that endowed professorships in marketing, finance, and economics.

Operation Bootstrap, designed at OU in 1952, allowed active-duty military personnel to finish college. These highly motivated students were given up to six months leave to accelerate their degree progress. During the peak year of 1964–1965, over 1,100 military personnel received their degrees; most, through the College of Continuing Studies, received a bachelor of general studies degree. The program generated about 20 percent of the university's revenue. Many bootstrappers belonged to the Pen and Sword Society.

The home economics program, like engineering, is linked to the Lincoln campus. Nila Magdanz, professor of Human Development and the Family, demonstrates to students the use of the oven in a modern kitchen in the 1970s. In 1983, the University of Nebraska–Lincoln had 900 majors and UNO had 270.

The women's athletic facilities in the 27-year-old Quonset hut were inadequate and "deplorable." They lacked privacy, leaked, and were noisy and poorly lit. Connie Claussen, B.A. (1961), chairman of women's physical education, repeatedly requested improved quarters. Women's athletics received no money in 1972–1973 compared to $200,000 for men, and $2,000 in scholarships compared to $47,000 for men. Title IX, designed by Congress to provide equal treatment for women on campus, brought federal authority to bear.

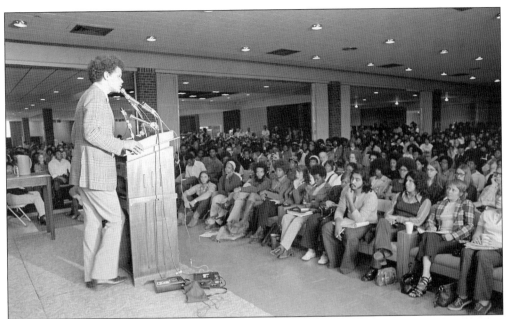

Julian Bond, Georgia democratic legislator and civil rights activist, sponsored by the Student Program Organization, addressed over 1,000 UNO students in October 1972 on the subject "New Politics: Myth and Reality." The *Gateway* headlines proclaimed "Bond Blasts Nixon Backers" and "Nixon Knocked by Julian Bond." Black Panther leader Bobby Seale addressed over 800 students at UNO on November 16, 1974.

The Goodrich Program, established in 1972, honored state senator Glenn Goodrich and provided access to college for low-income students, which included minorities, first generation in a family to enroll in college, and at-risk students. It occupied Annex 24, a home built in 1926. This picture of a reception for Goodrich Program students in the alumni house club room dates from 1987.

Marianne Young, a junior English major, in a behind-the-scenes photograph, prepares for her role as a nanny in *The Effects of Gamma Rays on Man-in-the-Moon Marigolds* by Paul Zindel in July 1973 for the UNO summer repertory theater. The *Gateway* reported, "An expert makeup and a near perfect performance by Marianne Young made the Nanny a memorable cameo. Though a non-speaking role, it requires intensive concentration on the part of a young performer." Young played Mrs. Crachet for 30 years at the Omaha Community Playhouse in *A Christmas Carol* by Charles Dickens.

The Lambda Chi Alpha fraternity crammed students into a Volkswagen in the 1970s. According to Google, *The Guinness Book of Records* states that 18 people squeezed into a Volkswagen Beetle. In 2006, 21 Malaysian students claimed to have squeezed into a Mini Cooper. During homecoming week in October 2006, the fraternity held a bounce-athon, with 48 hours of continuous bouncing on a trampoline to raise money for the North American Food Drive.

The four-lane bowling alley in the student center opened in October 1962. This picture dates from 1972. The new facility cost just under $62,000. Fees were $2.40 per hour and 15¢ for shoe rental. Most commercial alleys at the time charged 40¢ more per line. Although the facility could handle about 220 students per day, the alleys were eliminated when the space was reallocated in 1974.

Seen here is the record shop in the student center in 1972. Earlier in the 20th century, students participated in choirs, bands, and orchestras. The shop stocked about 1,500 records, vinyl 78s, 45s, and 33 LPs, mostly rock, soul, and jazz. They discounted $5.98 albums for $3.88.

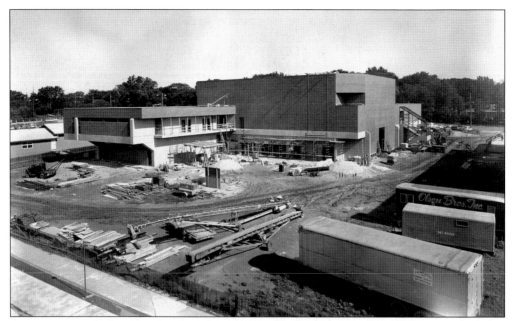

Shown here is the Janet A. and Willis S. Strauss Performing Arts Center. Private contributions combined with state and student revenues make it possible for quantum advances in programs and keep the campus up-to-date and aesthetically pleasing. The performing arts center, designed by Dana-Larson-Roubal Architects and dedicated in March 1973, bears the name of Janet and Willis Strauss, Willis being the director of Omaha-based Northern Natural Gas.

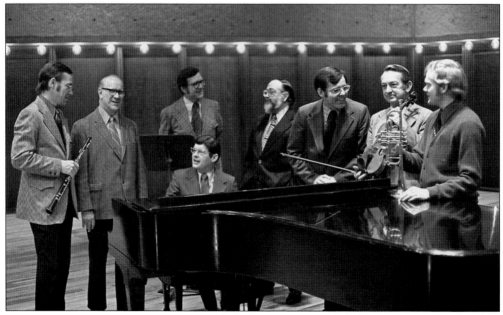

The UNO music faculty prepare, in the Strauss Performing Arts Center, to perform with the Town and Gown Orchestra in December 1973. The orchestra originated in 1917 as the Symphony Study Orchestra. Pictured here are, from left to right, Kermit Peters (conductor of the Town and Gown Orchestra), Raymond Trenholm, Robert Reutz, Harold Payne (at piano), Reginald Schive, Thomas Stapleton, Paul Todd (violinist), and Eugene Badgett.

98

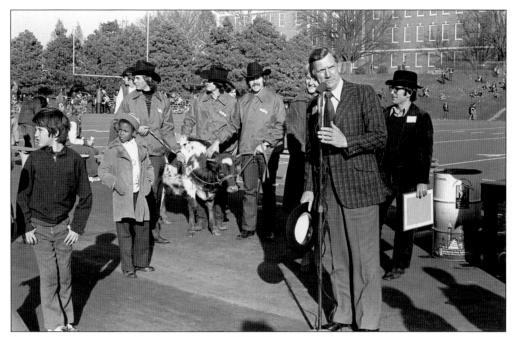

Nebraska governor J. J. Exon received the UNO Alumnus Achievement Award on November 17, 1973. Jim Leslie is at the right, and the debut of UNO Maverick mascot steer Victor is in middle. Exon attended OU from 1939 to 1941 and then entered the Signal Corps. Exon, a Democrat, served as governor (1971–1979) and in the U.S. Senate (1979–1997). Exon died in 2005.

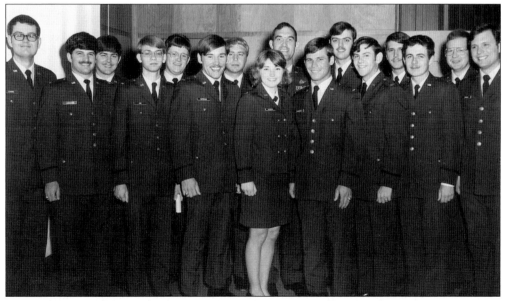

Laura Havelka, the first female UNO Cadet Corps commander and the first female to receive an air force commission at UNO, had a family history of flight. Her father was a pilot and her brother a navigator at Strategic Air Command. As commander she directed 72 men and five coed cadets. In 1973, the 21-year-old wore the homecoming queen crown. This picture is the Detachment 470 commissioning ceremony in May 1974. Cadet Corps commander Lt. Col. William A. Fall stands behind Lieutenant Havelka.

In 1971, the state legislature appropriated $3.7 million for a building to house the College of Business Administration, English and Political Science. Designed by Kirkham Michael and Associates and built by Peter Kiewit Sons' Company, and completed in 1974, the first floor of the five-story structure contained rotating pod "teaching stations" that could accommodate separate classrooms or a 388-seat lecture hall. The building was rededicated in November 2000 as the Ronald W. and Lois G. Ronald Hall.

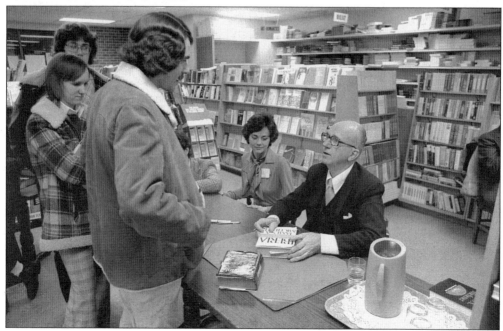

The ABC Breakfast Series, convened about three or four times a year, offered the opportunity for prominent politicians, government officials, best-selling authors, human rights activists, entertainers, and others currently in the news to share their ideas over breakfast. Here ABC (Academy, Business and Community) welcomes Pulitzer Prize winner James Michener.

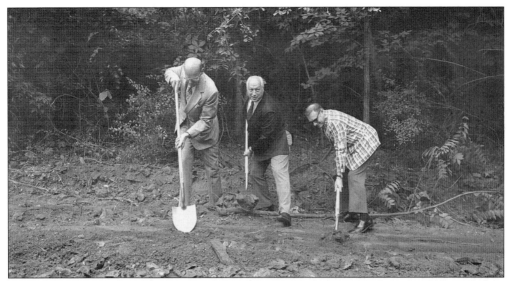

Groundbreaking for the new library occurred on July 31, 1974. UNO officials were joined by state senators John Savage, Glenn Goodrich, and David Stahmer, and librarians in turning the first shovels of earth. The library increased book capacity by one-third and more than doubled the seating capacity. From left to right are chancellor Ronald Roskens, regent chairman Kermit Hansen, and vice chancellor Herbert Garfinkel. Librarians during this period were John Christ (1970–1978) and Robert Runyon (1978–2000), who in 1987 prepared a traveling exhibition on Carnegie libraries.

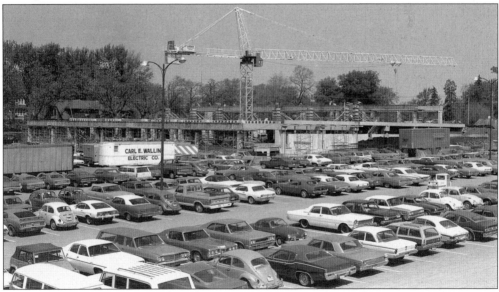

Surface parking adjoining the library under construction in 1975 reveals at least 10 Volkswagens, including 8 bugs, a Kharman Ghia, and a Volkswagen "The Thing," and 10 Ford Mustangs. Over two weeks in mid-1976 about 400,000 books were moved from the Eppley Library to the new library. Chancellor Roskens proclaimed at the dedication, "The very essence of learning and scholarship is contained in a library," and "This building with its modern capabilities also assures the learner of 1976, as well as the learners of 2000s, that the resources they need for the pursuit of human investigation will be provided in a manner commensurate with that greater purpose."

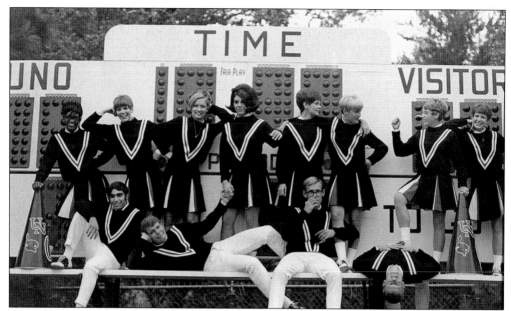

UNO's 1968–1969 cheerleader squad stands on the stadium scoreboard. Pictured are (first row) Gary Domet, Clark Rudeen, John Norton, and Chip Shaw; (second row) Stephanie Brown, Debbie Eggers, Sue Tokarski, Linda Kolell, Joan Fulton (captain), Joan Thomas, Robbie Sager, and Karen Rozgall. The *Tomahawk* described them as "eight attractive, energetic coeds and four exuberant males. Together they produce enough cheers to give any team with low spirits the will to win."

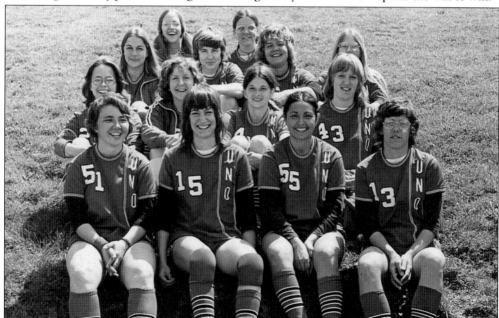

Connie Claussen coached the softball team to a 17-7 winning season and the 1975 national championship. In the same season coach Virgil Yelkin, in his 25th year of coaching the men's team, achieved his 400th career win. Women's athletics suffered financially, affecting the number of sports played, uniforms, athletic scholarships, trainers, and coaches, compared to UNO men's sports and women's sports at Lincoln.

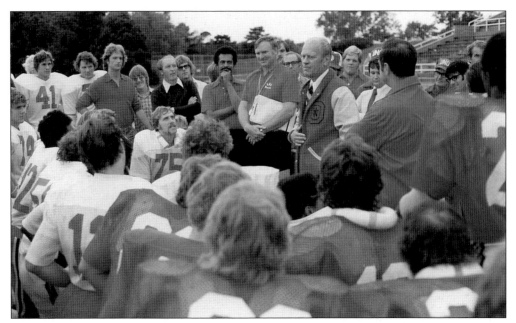

Former president Gerald R. Ford visited his Omaha birthplace on September 21, 1977. Besides several formal speaking engagements and a banquet, he huddled with the football team coached by Bill Danenhauer, at Ford's right. Ford had played on the University of Michigan's two national championship teams in 1932 and 1933. He turned down offers from the Detroit Lions and the Green Bay Packers and earned a law degree at Yale in 1941. He died in 2006.

The state-of-the-art HPER (health, physical education, and recreation) Building, designed by Kirkham Michael and Associates, opened in 1977. The photograph depicts the 500,000-gallon, 50-meter swimming pool under construction. It is accompanied by a stadium seating 850. UNO women's athletics joined Division II of the NCAA in 1981. The athletic hall of fame in the field house rotunda displays the pictures of almost 100 honorees, including Joe L. Arenas, Rod Kush, and Dean Thompson Jr. The field house contains decades of pennants reflecting sporting accomplishments.

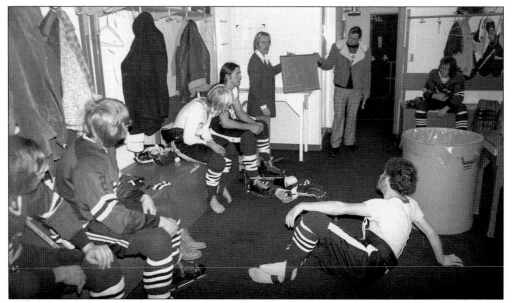

OU had a hockey club from 1948 to 1952. The sport revived during 1975–1976. Here coach Mike Kemp, from Minnesota, is giving a pregame talk in 1975. Hockey came to stay as an NCAS Division I program in 1996. Kemp returned again as the first coach in 1996. The first season starting in 1997 broke box office records with the sale of 6,389 season tickets. The team finished the first season 12-18-3 with an average attendance of 8,314. In 2004, Dan Ellis became the first UNO player to play in the National Hockey League.

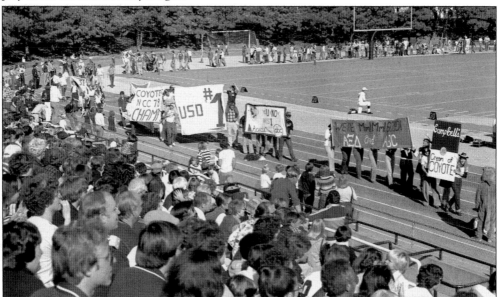

UNO Maverick football was on ABC regional television on November 4, 1978. While University of Nebraska–Lincoln games are regularly televised, Omaha's appearance on television is far rarer. WOW-TV Channel 6 carried the Omaha and Doane College game locally in November 1952. The UNO versus South Dakota game resulted in $6,000 for both schools while the remainder of the schools in the North Central Conference received $3,000 each. The season ended on a sour note as UNO lost 21-3.

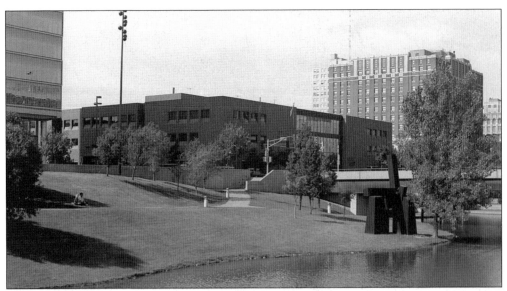

The redevelopment of downtown Omaha involved building a mall, a library, and corporate buildings. Construction mogul Peter Kiewit offered $2.5 million, other business leaders pledged an equal amount, and the state provided $10 million to build the Peter Kiewit Conference Center to house state offices and the College of Continuing Studies. It opened in December 1980. Financial exigencies curtailed the College of Continuing Studies and the downtown presence in 2000. This 1992 photograph includes UNO metal sculpture artist Sidney "Buz" Buchanan's six-ton *Mangonel II*. His sculpture *The Black Twist* stands on the western edge of campus.

The alumni association, organized in 1913, moved into the administration building in 1944, into the student center in 1960, and into the Storz Mansion in 1970. As the number of graduates went into the tens of thousands, in the words of the alumni association executive secretary in 1960, it was "bursting from one building to another." Fund-raising resulted in the acquisition of the residence at 6705 Dodge Street in 1981, which is now the William H. Thompson Alumni Center. The building underwent renovations in 1994 and 2005.

The Nebraska Shakespeare Festival, conceived in the early 1980s, produces two to four plays in Elmwood Park during the summer. It received support from Harold and Marian Andersen of the *Omaha World-Herald.* The initial flyer set the theme: "Come early, bring your blankets, picnic baskets and families to enjoy a full evening of outdoor entertainment." Thousands attend. The productions were directed by UNO's Dr. Cindy Phaneuf. Preperformance activities include jugglers, mimes, and discussion. Here Omaha violinist Deborah Greenblatt entertains in 1992.

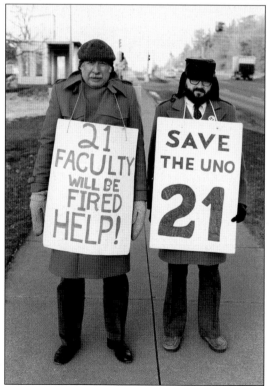

The American Association of University Professors, the faculty bargaining unit, negotiates contracts and defends academic freedom. Eugene Freund (left) from the College of Education and William Pratt of the history department carry placards on Dodge Street in January 1984 to increase public awareness regarding the position of the regents that a salary increase would cost jobs. Upon completion of negotiating a two-year contract, UNO academic vice chancellor Otto Bauer, who took this picture during negotiations, presented it to Professors Freund and Pratt. No jobs were lost.

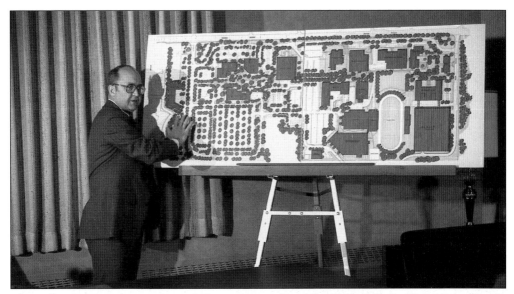

Chancellor Del D. Weber explains UNO expansion plans. The Citizen's Action Association fought against the "land grab" that threatened its neighborhood. As the student population increased and new facilities were needed, expansion raised issues with conservationists and city planners. The former nunnery became the location of the College of Public Affairs and Community Services in 1972. Other homes were leveled. In 1983, the university received the regents' approval and $3.2 million to purchase 12 homes. By the mid-1990s UNO shifted from westward to southward expansion with designs extending to Pacific and Center Streets.

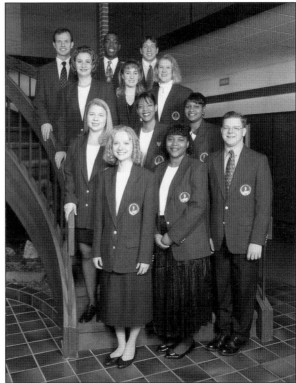

Vice chancellor for educational and student services Richard Hoover introduced the UNO ambassador program in 1982. A total of 12 students, selected for academic achievement, leadership, and communication skills, served as hosts and official greeters for designated university functions. Pictured here in 1997–1998 are, from left to right, (first row) Debbie Clute, Chiara Smith, and Stephen Croucher; (second row) Nif Camden, Melinda Gardner, and Sandra Foster; (third row) Laura Setlak, Amanda Lovell, and Kenna Butler; (fourth row) Larry Several, David Anthony King, and Clark Diffendaffer.

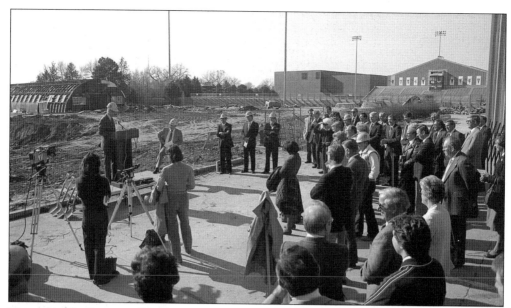

The parking facility groundbreaking ceremony took place on November 14, 1984. UNO, a commuter campus, needed space to park cars. The move to West Omaha at Sixtieth Street placed emphasis on individual transportation and the automobile. As enrollment grew to five figures, parking spaces for students and faculty became a premium. In 1975, UNO contracted with Ak-Sar-Ben for 350 parking spaces and provided shuttle bus service. After years of complaints, Kiewit Construction Company built the three-story structure.

Each floor of the UNO three-level parking structure under construction in May 1985, built at a cost of $8 million, covered 3.5 acres. The parking structure opened in January 1986. The construction of this parking structure had the added benefit of the removal of the temporary annexes (see previous image upper left). Leo A. Daly construction estimated that the campus needed 5,400 parking spaces and should plan for 6,000, and the campus settled at 4,800 spaces.

The Casavant Opus 3603 pipe organ assembly built in Quebec weighs 17 tons, is 28 feet tall, and has 50,000 pieces. The turntable recital hall seats 500. The Omaha Symphony Chamber Orchestra performs here as well as traveling groups and other recitals. Friends of Janet and Willis Strauss donated the organ, which is located in the Strauss Performing Arts Center, to UNO.

Paul Borge, campus radio and television manager, reviews a "Reflection in Time" interview with Ralph Wardle in 1986. Borge arrived at OU in 1956 and for many years provided the voice of the university as he interviewed scores of faculty and personalities on current events and their careers. Many of these tapes have been preserved and provide an oral history of the university. Borge died in 1999.

Harry Duncan, born in 1916, graduated from Grinnell College and became a preeminent fine art printer at the University of Iowa in Iowa City. He published under the imprints of the Abattoir and the Cummington Press. He came to UNO in 1972. He has been described as "the father of [the] post-World War II private-press movement" and honored by Tom Taylor's *A Garland for Harry Duncan* (1989). The book arts program has been continued by Bonnie O'Connell and Denise E. Brady. Duncan died in 1997.

Dr. David Low, the Kayser Distinguished Professor of Music, is an internationally acclaimed cellist. A graduate of the Eastman School of Music, Stanford, and Northwestern University, he has performed at Carnegie Recital Hall in New York, with the Bejing Film Philharmonic Orchestra in China, and in Lithuania, Latvia, Estonia, and Russia, as well as with the Nebraska Arts Council Touring Program, Community Connections, and Mannheim Steamroller. Here he is giving a cello lesson to graduate student Beverly Daw in 1986.

110

In 1984, the Nebraska Unicameral appropriated $9.5 million for a science center. Private gifts totaled $5 million. Charles and Margre Durham made the largest single contribution. Designed by Henningson, Durham and Richardson, it was built by Peter Kiewit Sons and dedicated in September 1987. The three-story Durham Science Center houses mathematics and computer sciences, chemistry, physics, geography/geology, and the Remote Sensing Applications Laboratory. Athena Tacha's "Link," 25 columns inscribed with the names of four millennia of scientists, is on the building's west side. UNO engineering professor Bing Chen moved the Japanese-style building in the foreground, the former home of the UNO art gallery, to Seventieth Avenue in 1990.

The Mallory Kountze Planetarium is named for a president of the Gilbert M. and Martha H. Hitchcock Foundation, a major Omaha educational benefactor. The 33-foot-high domed planetarium has state-of-the-art optics and electronics from Spitz, Inc., of Chadds Ford, Pennsylvania. A public planetarium, it seats more than 50 people. In 2002, the planetarium temporarily fell victim to budget cuts and discontinued its laser magic show. It was renovated and reopened in late 2005 as a technology enhanced "smart classroom."

The groundbreaking ceremony for the Henningson Memorial Campanile, on May 12, 1988, introduced a new campus icon. Campaniles, with elevated clock and chiming bells, found on many campuses, represent the continuity of culture and the aspiring academic community. Pictured here from left to right are University of Nebraska Regent Nancy Hoch, Charles Durham, Margre Henningson Durham, chancellor Del D. Weber, and University of Nebraska foundation president Terry L. Fairfield. The tower is dedicated to Margre Durham's father, mother, and sister, Henning H., Rose P. Henningson, and Helen Henningson Grimes.

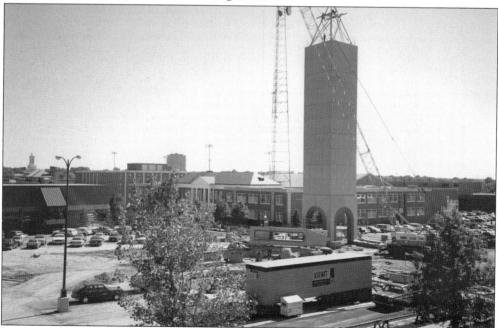

Henningson Memorial Campanile is seen on October 5, 1988. The tower competes with the cupola on the Arts and Sciences Hall as the UNO icon (the 1938 cupola had been designed to receive bells). The 168-foot-high campanile, designed by Robert A. Torson Architects, contains a carillon of 47 bells. The bells, weighing 12 tons, were cast by the Paccard Foundry in Annecy, France.

112

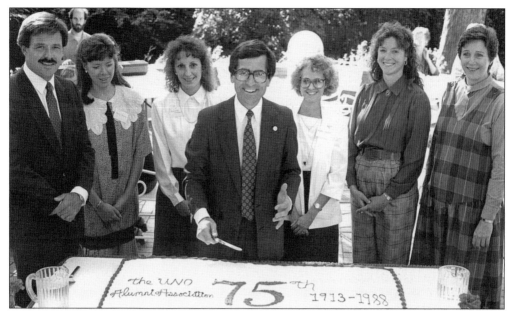

The UNO Alumni Association celebrates 75 years in 1988. From left to right are Dan Devere (associate director), Mary Kenny (communications), Roxanne Hansen (secretary), Jim Leslie (executive director), Kathy Snail (receptionist), Cathi Sanchez (reservations), and Anne Packard Kotlik (accountant). Leslie entered OU in 1959, served as president of the student council, chaired the student committee promoting the 1963 mill levy, and graduated in 1963. He directed the alumni association, from 1973 to 2006, during which time more than 50,000 graduates were added to the rolls. The association sponsors scholarships and several professorships. Chancellor Weber stated, "Jim bleeds Crimson and Black," UNO's school colors.

The need for on-campus day care, identified in 1981–1982 by the Women's Resource Center, moved closer to realization in 1986 with the acquisition of property on the west side of campus. Renovating Annex 47 provided accommodation for 63 children ages 18 months to six years. Families with two or more children received a discount. The children are visiting the Eppley Administration Building in December 1988.

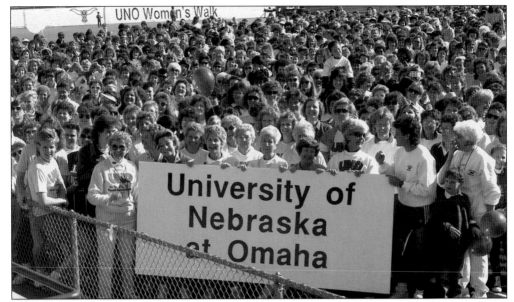

In 1986, Connie Claussen and Lou Ann Weber, wife of chancellor Del D. Weber, and 85 walkers raised $12,000 for women's athletics. In 1988, 600 walkers collected $60,000. In 1989, Diet Pepsi sponsored the April 15 UNO Women's Walk fund-raiser involving 1,300 women, including Gov. Kay Orr, which raised $70,000. A taped 10-second greeting aired on *Good Morning America* on May 22, 1989. The open house for Celebrate UNO, April 15–16, 1989, attracted between 12,000 and 14,000 visitors.

In October 1990, ground was broken for the Fine Arts Education Building. Designed by Roger Wozny of Schemmer Associates, the building combined medieval tower construction and avant-garde waving exterior walls. It houses the departments of art, dramatic arts, an art gallery, a fine arts press, the Nebraska Center for Book Arts, and the writer's workshop, and includes a 250-seat experimental theater. The building opened in 1992 and was renamed the Del and Lou Ann Weber Fine Arts Building in 1998.

Andrew Leicester designed the amphitheater adjoining the fine arts building. The Castle of Perseverance is based on a medieval play and purports to "use the power of the arts to purify the human spirit." Funding came from the one percent art program and a grant from the National Endowment for the Arts. The space opened in October 1993.

In the late 19th century, libraries shifted from ledgers and printed catalogs to card catalogs. On August 23, 1990, UNO converted to an online catalog as library director Robert Runyon, at the podium, opened GENYSIS (General Information System). Some 29 cabinets with 2,028 drawers and about 3,215,000 cards were eliminated. The speed and ease of keyword search capability quickly won over scholars.

UNO students campaign against measure 405, a two percent lid on November 6, 1990. Ed Jaksha, a one-issue politician, wanted to cut taxes. Measure 405 proposed to limit state and local budgets increases to two percent. The Lid Bill lost by almost 2 to 1. About 390,216 people voted against the proposal, 175,538 supported it. A similar proposal was rejected by the electorate in November 2006.

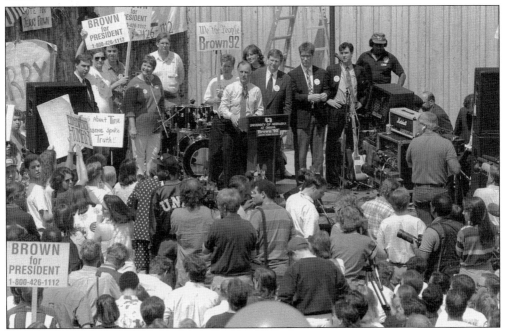

California governor Jerry Brown ran for president in 1992 and spoke on campus. Other national politicians appearing on campus include candidates George Wallace and John Kerry. The lecture circuit brought political personalities such as John Dean.

Vice Pres. Al Gore toured the country promoting the Clinton administration's Democratic initiatives. On March 10, 1993, an audience of over 300 people in the fine arts building, including chancellor Del D. Weber, Gov. Ben Nelson, Omaha mayors Michael Boyle and P. J. Morgan, and Congressman Peter Hoagland, heard Gore push the administration's economic growth policy. A student asked about the faltering student loan program. The *Gateway* recorded Gore's closing words: "Break the gridlock, end the status quo, help us put people back to work, bring interest even farther down, invest in our future and start moving America in the right direction."

The 1996 UNO Maverick volleyball team, 35-2, was the NCAA Division II national champion. Rose Shires coached the volleyball team since 1990. Her 284-146 record includes three NCAA Division II tournament appearances. In 1996, the team won the national championship by defeating the University of Tampa at Warrensburg, Missouri. The *Gateway* reported coach Shires's eloquence: "It's how I think we all dreamed it would turn out. This championship is, without a doubt, the most important thing that's ever happened to me because I know how hard these people have worked. I know what they sacrificed to get here."

The removal of asbestos and remodeling the Arts and Sciences Hall in 1994 replaced the two-story theater with international studies on the second floor and forensics and classrooms on the ground floor. The one percent for art from state funds provided the most delightful enhancement. More than 200 artists competed for the commission. Julie Rezac Van Mierlo highlighted the 26 letters of the alphabet in slate and marble, weighing about 100 pounds each, depicting the alphabet from cave paintings through binary code, and accompanied by a poem or epigram. Shown here are *E* (Phoenician), *G* (Roman), *H* (Hebrew), *J* (Arabic), *R* (American Secretarial Hand), *S* (Show Advertising Display), *T* (William Morris, Kelmscott Press Chaucer), *X* (International Pictograph), and *Z* (binary code). Van Mierlo of Bennington, Nebraska, trained as a letter cutter in England. *The Alphaforms* unveiling occurred in February 1997.

Six

ADJUSTING TO THE
INFORMATION AGE
1997–2006

The arrival of Nancy Belck as chancellor, in an era of rising costs and wavering state support, prompted reevaluation of the university mission. Emphasis shifted to a somewhat younger student clientele, raising entrance requirements, and minimizing attrition, a problem at commuter campuses. The First Year Experience program addressed student academic survival skills to maximize retention. Opening residence halls contributed to the quality of university life. The College of Continuing Studies curtailed its downtown program serving predominantly working students. The south campus adjacent to First Data Resources, conceived during the Weber administration, blossomed under chancellor Belck.

The emphasis on hiring and promoting qualified women and minorities continued. Dr. Gail F. Baker, appointed dean of the College of Communications, Fine Arts, and Media in mid-2006, was the first woman of color to head a UNO college. Janice Boyer directed the library from 2001 to 2004.

The university, founded on Christian principles in 1908, incorporated chapel as part of student life. The role of religion on campus receded during the municipal years. The University Religious Center initially served Lutherans, Methodists, Presbyterians, Baptists, Catholics, Quakers, and Jews. African Americans celebrating Kwanzaa, and the Islamic faith enhanced campus religious diversity. As the number of foreign students rose, the burka and chador became increasingly common. In 1991, UNO embarked on an international archaeological project at Bethsaida in Israel.

Belck's administration ended in September 2006 in the wake of an athletic budget controversy. Scrutiny by major donors, the *Omaha World-Herald,* and central administration in Lincoln made her continuing leadership untenable, a disappointing ending to a rather productive nine-year chancellorship.

OU in 1910 contemplated two men's and one women's dormitory. Urban commuter campuses do not usually accommodate residential students. By 1970, the university hired a director of housing to assist students searching for convenient off-campus rental accommodations. During the 1980s, long-range planning called for on-campus student housing to enhance the quality of campus life. The private residences on the west side of campus that served as offices for programs such as criminal justice faced the wrecking ball to make way for residence halls. University Village, with 576 tenants in 144 suites, opened in 1999. In early 2007, the regents authorized new apartment-style residence halls expected to house 400 students, bringing on-campus housing to 1,220 units.

Chancellor Nancy Belck, the university's first female chief executive, came to UNO from Southern Illinois University in Carbondale where in 1994 she served as their first female president. She is pictured here on October 8, 1998, with several generations of university leaders. From left to right are Del D. Weber, Ronald Roskens, Nancy Belck, Daniel Jenkins Jr., and Kirk E. Naylor.

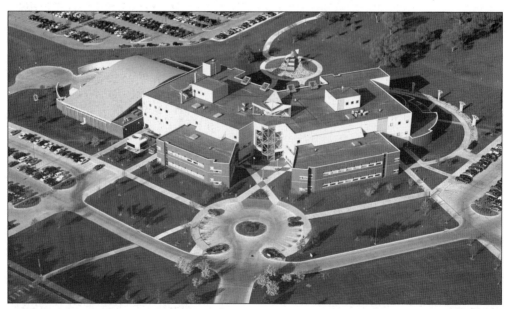

Ak-Sar-Ben, founded in 1894, declined with the legalization of gambling in Council Bluffs and off-track betting. The vacant racetrack and stadium provided the university an opportunity to grow to the south. The Peter Kiewit Institute, dedicated in August 1999, houses the College of Information Science and Technology (IST) and College of Engineering and Technology. Measuring 17 feet by 7 feet and 3 inches, Dale Chihuly's red glass sculpture *Toreador Red Chandelier* hangs in the triangular three-story IST entrance. Banners proclaim "Education moving at the speed of business."

120

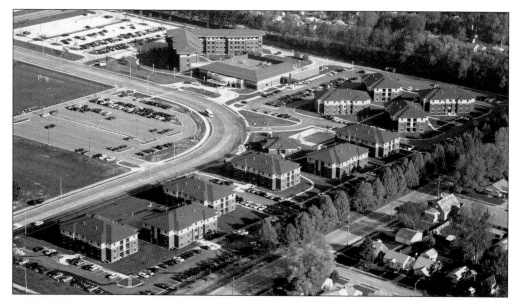

In 1999, the regents, assisted by the Suzanne and Walter Scott Foundation, approved the construction of 164 units in four-story student housing on the Ak-Sar-Ben campus. They opened in 2000. Scott Village and Scott Residence Halls and Conference Center maintain a collegiate philosophy of college housing and opened an additional 480 units in 2003. Residence halls may have contributed to the rising retention of first-year students after 1997.

Geographer Christian Jung started the Afghanistan Study Center in 1972. Following his untimely death, Thomas Gouttierre, former Afghanistan Peace Corps director, became dean of international studies in 1974. Arthur Paul, economic adviser to the Royal Government of Afghanistan, 1960–1965, donated several thousand Persian-, Pashto-, and English-language books on Afghanistan. On May 25, 2005, Afghanistan president Hamid Karzai received an honorary doctorate of humane letters; he is flanked by Gouttierre and chancellor Nancy Belck.

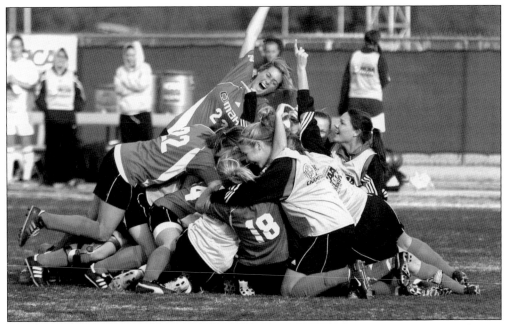

The UNO soccer team celebrates after winning the NCAA Division II national championship on December 3, 2005. The women's soccer team had made it to the final four of the NCAA Division II three times. The fourth time they prevailed and won the national championship. This scene is reminiscent of the U.S. women's soccer team victory in the 1996 Olympics.

The Nest by Bart Vargas, representing knowledge, technology, literacy, and creativity, is in the library entrance. The installation weaves computer parts, cords, and power strips. The beach ball–size egg made from keyboard keys is reminiscent of the 1970s IBM Selectric type ball.

Seven

CONCLUSION
POISED FOR THE CENTENARY

John Christensen, M.S. (1974), former dean of the College of Education and academic vice chancellor, became interim chancellor in September 2006. When the school opened in 1909, student fees were $60 annually. Almost a century later, the fees are about $4,700 annually. Enrollment rose from 9,082 in 1965 to 14,693 in 2006. The school motto, "To earn a living and live a cultured life not as two processes but as one," continues as the university mission. UNO approaches its second century alert to intellectual frontiers, a well-rounded education, and the role of sports and extracurricular activity in higher education. The university provides students the opportunity to find the right balance between their intellect, skills, and interests to lead a productive life after college. Some students go on to achieve in business, education, politics, government, medicine, law, sports, and other arenas of worthy endeavor. Their success reflects well on the individual and the institution.

University faculty go beyond the classroom to influence public policy as "public intellectuals." Elected public officials include school board members Paul C. Kennedy, Bernie Kolasa, and John Langdon, all of whom served as president, and city councilman Franklin Thompson. Some attempt to influence the public through the *Omaha World-Herald*, which publishes from 25 to 45 essays a year by Nebraska academics at UNO, Creighton University, the University of Nebraska Medical Center (UNMC), the University of Nebraska–Lincoln, the University of Nebraska at Kearney, and Bellevue. Prominent among *World-Herald* "Other Voices" and "Midland Voices" columnists in the last decade are Charles Gildersleeve (geography), Lourdes Goviea (sociology), Bruce Johansen (journalism), Oliver B. Pollak (history), and Sam Walker (criminal justice).

The library stands at the heart of the university. UNO does not receive the 10,000 items per day that arrive at the Library of Congress, but it provides students, faculty, community, and distance learners access through online sources and interlibrary loan.

Donors endowed lectures open to students and the public, including the Rabbi Sidney H. Brooks Lecture in Religion (rabbi of nearby Temple Israel), the Shirley and Leonard Goldstein Lecture on Human Rights (Shirley Goldstein is an indefatigable advocate in behalf of Soviet Jews), and the Richard Winchell Annual History Lecture (bachelor of science in education, 1952; master of science in education, 1959; president of Bellevue University). George J. Shuflata Jr., B.G.S., M.A. (1967 and 1976, respectively) and Charles and Mary Martin displayed their love of learning by endowing research and scholarship. The future well-being of the university relies of a combination of alumni, public, corporate, and state support.

The renovated expanded library was rededicated on October 11, 2006, as the Dr. C. C. and Mabel L. Criss Library and the Dr. Guinter Kahn Addition. From left to right are former U.S. senator from Nebraska David Karnes, University of Nebraska president James B. Milliken, library director Stephen Shorb at the podium, Dr. Ben Nachman (representing Dr. Kahn), Terry Fairfield (president UN Foundation), Dr. Stanley Davis (representing Criss Foundation), regent Drew Miller, interim chancellor John Christensen, student regent Steve Massarra, faculty senate president James Shaw, and staff advisory council president Mary Sweaney. Criss had been a president of Mutual of Omaha. Kahn (OU, 1956) left Germany in 1938, earned his medical degree at UNMC, and developed the hair growth stimulant Rogaine.

The psychology department claims at least two distinctions. In cooperation with the University of Nebraska–Lincoln, the psychology department started a doctoral program in 1972, and to date about 80 degrees have been awarded. The department, a potent source of university leadership, provided several arts and sciences deans: William H. Thompson (1942–1960); Jack Newton (1974–1995); and Shelton Hendricks, who joined the faculty in 1969 and served as graduate college dean before becoming arts and sciences dean in 2001.

Academic conferences foster the exchange of ideas and publications. The Missouri Valley History Teachers Conference, founded in 1957, soon became the Missouri Valley History Conference. It celebrates its 50th year in March 2007. The conference brings scholars to Omaha from around North America. Other UNO conferences include the European Studies Conference established in 1975 and the Third World Studies Conference established in 1977, which became the Global Studies Conference.

The university has been the subject of satellite photographs and photographs taken from lower-flying aircraft. The western edge houses the Goodrich Program and gerontology, public administration, the School of Social Work, facilities management and planning, a child care center, and landscape services in what were once private dwellings.

BIBLIOGRAPHY

Applehans, Denver. "Math and Physics Department at the University of Omaha." Typescript, University of Nebraska at Omaha, 2006.

Barth, Brandon. "'To Produce Intelligent Musicians of Liberal Culture': Music and the University of Omaha." Typescript, University of Nebraska at Omaha, 2004.

Bonner, Thomas N. "The Devil They Knew: Adventures in Higher Learning." Typescript, University of Nebraska at Omaha, 2002.

Campen, Lillian Henderson. "The Early History of the University of Omaha." Typescript, University of Nebraska at Omaha, 1948 and 1951.

Dalstrom, Harl Adams. *Eugene C. Eppley: His Life and Legacy*. Lincoln, NE: Johnsen Publishing, 1969.

———. *A. V. Sorenson and the New Omaha*. Omaha, NE: Lamplighter Press, 1987.

Foght, Harold W. *A Survey of the Municipal University of Omaha*. Omaha, NE: 1932.

Forss, Amy. "An Evolving Structure: The University of Omaha, 1908–1938." Typescript, University of Nebraska at Omaha, 2006.

Helligso, Martha Stuart. "The Administrative Development of Graduate Education at the University of Omaha, 1909–1968." Master's thesis, University of Nebraska at Omaha, 1971.

Larsen, Lawrence H., and Barbara J. Cottrell. *The Gate City: A History of Omaha*. Boulder, CO: Pruett Publishing, 1982.

McMahan, Tim S. "UNO's First Home." *UNO Alum* (Summer 1996): 20–21.

Mihelich, Dennis N. *The History of Creighton University, 1878–2003*. Omaha: Creighton University Press, 2006.

Pollak, Oliver B. "Fifty Years of Teaching History at Omaha University, 1908–1957." *Journal of the West* 42 (Summer 2003): 75–82.

———. *To Educate and Serve: The Centennial History of Creighton University Law School, 1904–2004*. Durham, NC: Carolina Academic Press, 2007.

———. "Howard Buffett and Omaha University: A Tale of an Unendowed Chair." *UNO Historian* 10 (2001): 9–11.

Pollak, Oliver B., and Aneta Czarnik. "The UNO Public Intellectual and the *Omaha World-Herald*, 1997–2006." Typescript, University of Nebraska at Omaha, 2007.

Thompson, Paul. "'Known for Its Learning': The History of the University of Omaha Law School, 1893–1942." University of Nebraska at Omaha, 2005.

Thompson, Tommy. *History of the University of Nebraska at Omaha, 1908–1983*. Dallas: Taylor Publishing, 1983.

White, Terry. "AHAMO, Conflicts in Omaha in 1935." Typescript, University of Nebraska at Omaha, 1982.

INDEX

www.arcadiapublishing.com

Discover books about the town where you grew up, the cities where your friends and families live, the town where your parents met, or even that retirement spot you've been dreaming about. Our Web site provides history lovers with exclusive deals, advanced notification about new titles, e-mail alerts of author events, and much more.

MADE IN THE

Arcadia Publishing, the leading local history publisher in the United States, is committed to making history accessible and meaningful through publishing books that celebrate and preserve the heritage of America's people and places. Consistent with our mission to preserve history on a local level, this book was printed in South Carolina on American-made paper and manufactured entirely in the United States.

Find Your Place in History.